Beginning
WATERCOLOR

Tips and techniques for learning to paint in watercolor

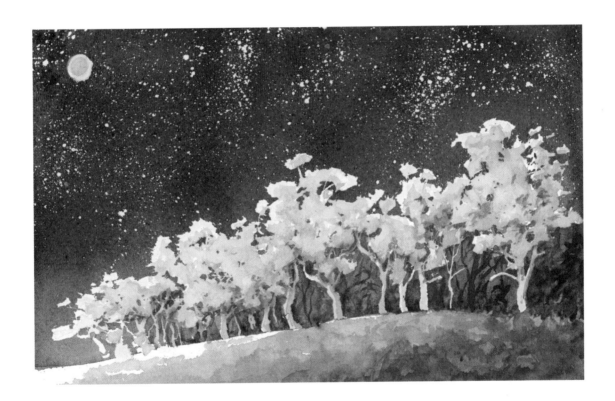

Quarto is the authority on a wide range of topics.
Quarto educates, entertains, and enriches the lives of our readers—
enthusiasts and lovers of hands-on living.
www.quartoknows.com

Artwork © Maury Aaseng

Cover Design: Jacqui Caulton
Design: Melissa Gerber

6 Orchard Road, Suite 100
Lake Forest, CA 92630
quartoknows.com

Visit our blogs at quartoknows.com

Printed in China
5 7 9 10 8 6 4

MIX
Paper from
responsible sources
FSC® C016973

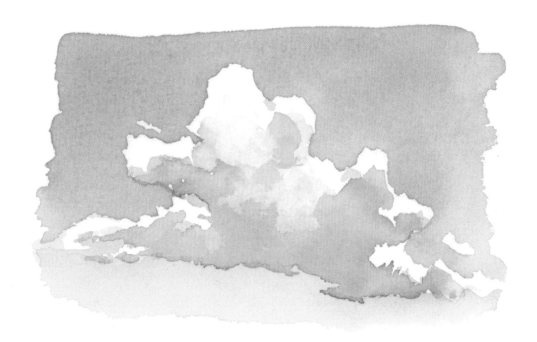

Table of Contents

Introduction

Painting with watercolor is a dance between pigment and water that creates images that other painting techniques can't capture. The soft edges and the pigment flow create images of ethereal beauty and vibrant intensity. Watercolor can produce works that resemble a faded memory, capture the mystic nature of light and atmosphere, and render subjects as highly detailed or veiled and impressionistic.

The variety of subject matter is almost matched by the variety of techniques that can be used to harness this painting style. In this book, you will learn how to begin painting with watercolor through examples and exercises that will help you master the techniques.

Be prepared to get wet, and yes, occasionally frustrated. But also prepare to be amazed at what you can create as you develop your skills in a medium that can be explored over a lifetime!

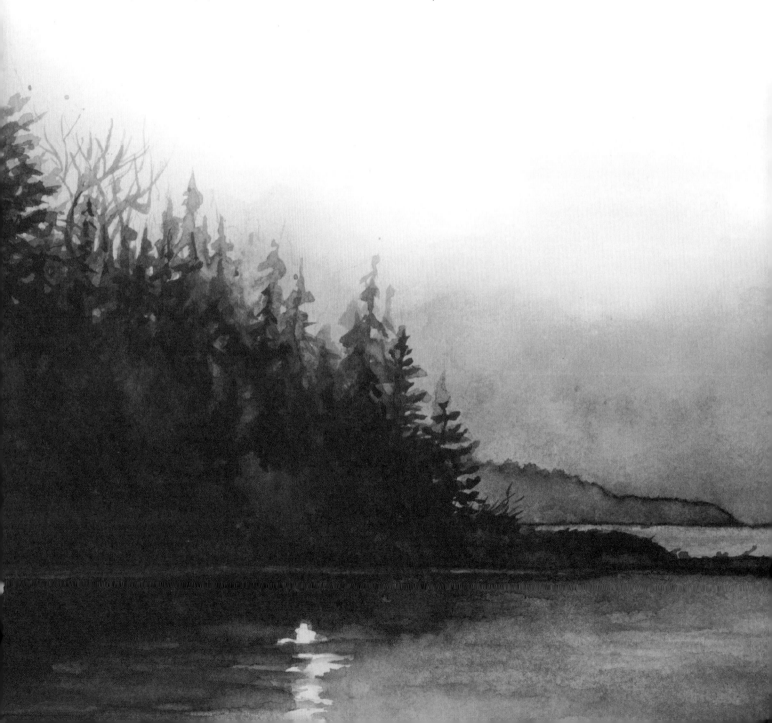

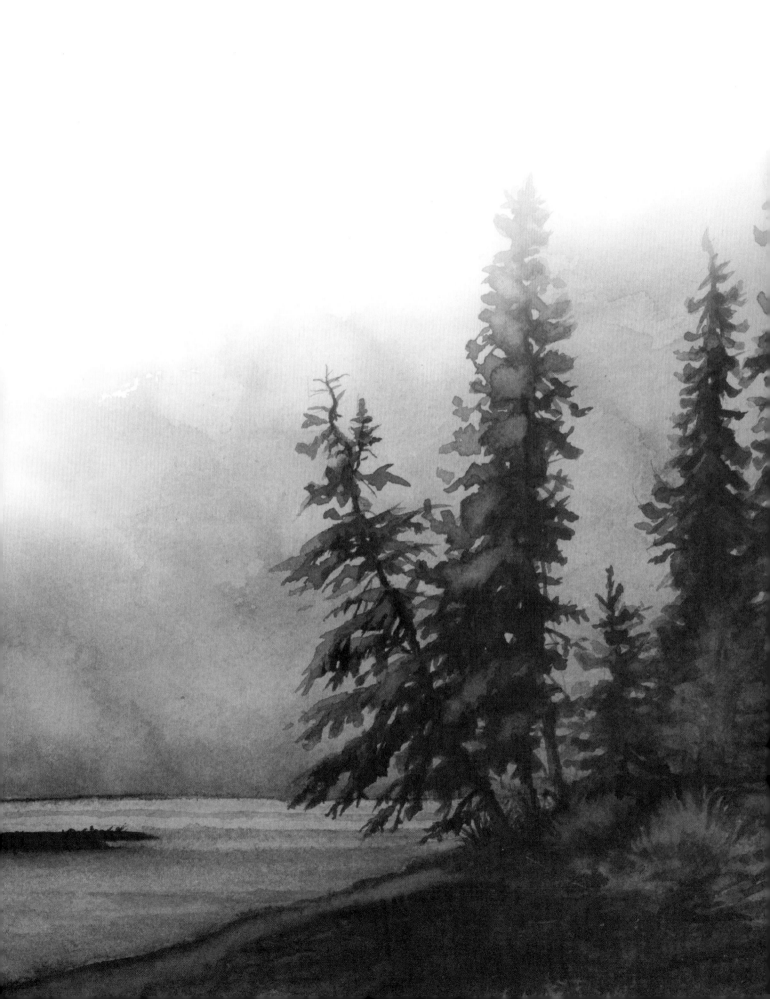

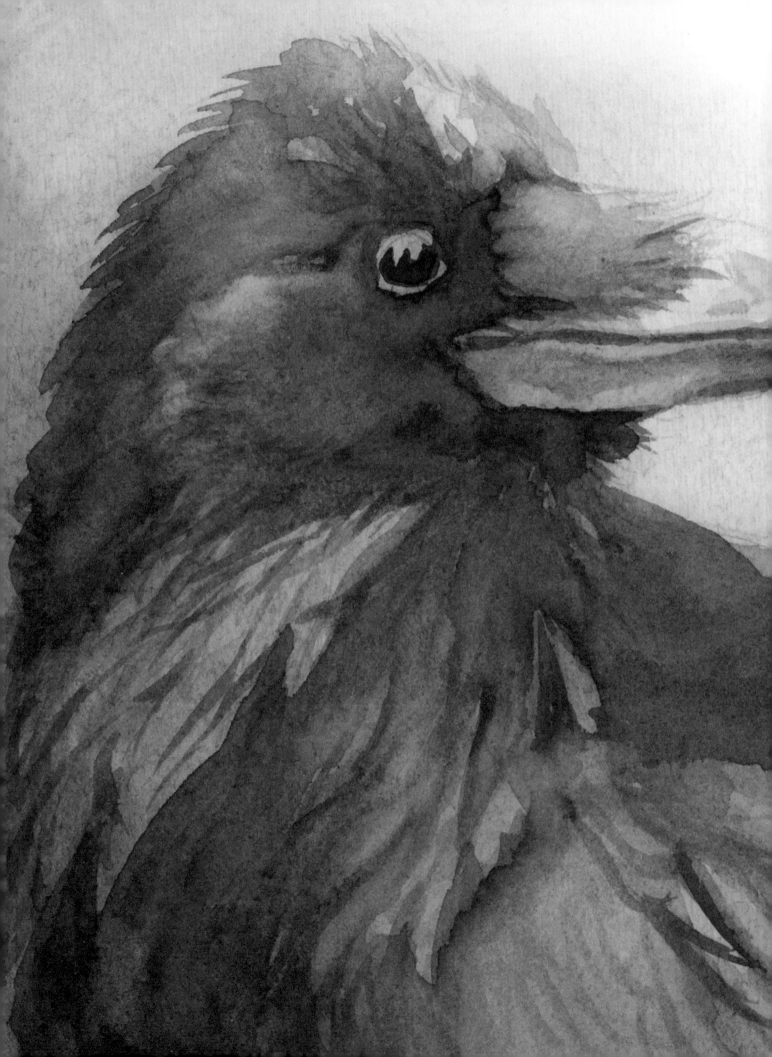

GETTING *Started*

What You'll Need

Learning how to use a few essential tools, including brushes and other equipment, will help you immensely as you begin your watercolor-painting journey.

ROUND BRUSH: The universal brush for watercolor, a round brush is easy to control and can create a variety of thicknesses. A brush with a pointed end can be used to create a wide or fine stroke, depending upon whether pressure is applied with the base or the tip of the brush. A blunted brush has less variety but greater consistency of stroke width.

A useful skill to practice is creating strokes close together. Start by creating one wavy brushstroke, varying the pressure to achieve different thicknesses. Add additional strokes, leaving just a little space between each. This technique helps you gain control of the brush and understand how to paint accurate shapes and lines.

FLAT BRUSH: A flat brush can create strokes, shapes, and thicknesses that a round brush cannot. Brush bristles are composed of either synthetic hair or natural animal hair.

A synthetic flat brush creates a stroke with less texture. Water drips off the brush with less consistency than from a natural brush, which results in the brushstrokes randomly dispersing more or less pigment. With a natural-hair flat brush, the texture of the bristles is evident, and the pigment is released more uniformly.

Synthetic flat brush

Natural flat brush

ANGLED BRUSH: This highly versatile brush can create the fine tips of a pointed round brush and the wide strokes of a flat brush. By twisting the brush as you paint a wavy line, you can create an incredible stroke variety. An angled brush is also a very effective tool for creating natural-looking features such as flowers (see page 44) and trees (page 50).

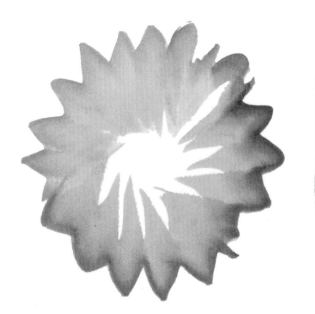

USING *two* COLORS AND AN ANGLED BRUSH, YOU CAN CREATE INTERESTING SHAPES. THE SAME IS NOT POSSIBLE WITH A ROUND OR FLAT BRUSH.

MORE ON BRUSHES

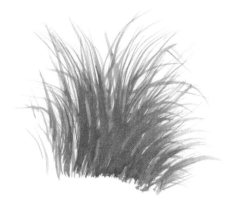

SYNTHETIC FAN BRUSH: Wetting a synthetic fan brush with paint tends to make its bristles clump together. This allows for a jagged edge at the tip of the brushstroke and a wide body at the base.

NATURAL FAN BRUSH: A natural fan brush doesn't release pigment as irregularly as a synthetic brush. Wetting the brush clumps the hairs, though not as drastically, creating a blunter point.

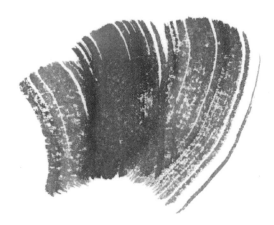

SCRIPT/RIGGER BRUSH: This narrow-bodied brush can be difficult to control due to its bristle length, but it creates fine lines that add nice details when painting landscapes and objects.

MOP BRUSH: This brush has soft, poufy bristles without a point. Though the mop brush's stroke is irregular and without distinct form, the water intermingles and flows to create visual interest, irregular textures, and compelling shapes.

PALETTE KNIFE: This features an angled handle, which allows you to scrape the flat bottom on your painting without dragging your knuckles across it. To use, mix a large puddle of pigment on your palette, and dip the bottom of the knife in the paint. The standard stroke, which is made by pulling the tip of the knife along the paper, can be used for detail work and fine lines. Dragging the knife sideways creates an interesting, irregular stroke that works well for texture in trees, rocks, and other natural objects.

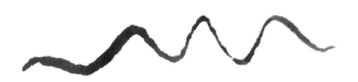

SPONGE: To use a sponge, dunk it in water, and wring it out. It should be damp, not sopping. You can dip the sponge in paint, or use a brush to apply paint to it. Sponges are sold in synthetic and natural varieties. Synthetic sponges come in regular shapes, like circles and squares. Dabbing with this type of sponge creates a more distinct and regular pattern. Natural ocean sponges come in all kinds of shapes and create texture with less-recognizable patterns.

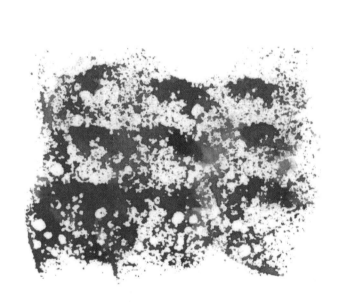

Synthetic sponge

Natural sponge

MOVING BEYOND BRUSHES

There are many other tools to keep in your kit that may not seem as obvious at first. We will explore how to use some of these starting on page 20.

SALT: You can use salt to create textures in your paint that are impossible to achieve with a brush.

SPRAY BOTTLES: These help create soft transitions in color without any brushstrokes. When filled with clean water, they are also handy tools for rewetting your surface if it dries too fast. You can purchase one from an art-supply store, or repurpose an old spray bottle.

MASKING FLUID: You can apply this liquid latex to subjects and areas of your painting to preserve the color of the paper or paint while working around it.

PALETTE: There are so many different kinds of palettes to choose from that it can be difficult to know what to look for. For the most part, any will work in at least some capacity. I look for a palette that has enough paint wells, or divets, to hold a variety of pigments and a wide mixing well. A palette with a flat bottom keeps dirty water away from clean pigment.

PAPER TOWEL: As close to an eraser as you will get with watercolor, towels or tissues can be used to lift color from your painting. They can also be used to paint atmospheric conditions, such as mist, clouds (page 56), and smoke.

PLASTIC WRAP: Another surprising tool, plastic wrap can be used to create interesting backgrounds and hard-to-paint textures, such as rocks (page 40) and frost-covered windows (page 30).

TOOTHPICKS: These are very handy for applying masking fluid to tiny areas, so keep a small stash of toothpicks at all times!

TOOTHBRUSH: Establish interesting patterns by dabbing paint with a toothbrush. It can be especially useful to create a spatter effect.

WATER BOWL: You can't paint without a container that holds water. Change the water frequently to avoid "muddying" the paint on your paper.

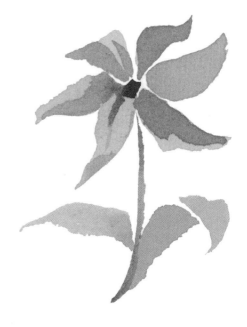

Playing with Color

To begin watercolor painting, you don't need every paint color on the market. However, you should understand the properties of the colors you do have. Before you start a painting, consider a color scheme for it. Many common color schemes are based on the color wheel. You can even paint your own color wheel, and consult it when trying to determine a color scheme for your painting. Consider which colors you want to emphasize as well as which colors work best together for your desired result.

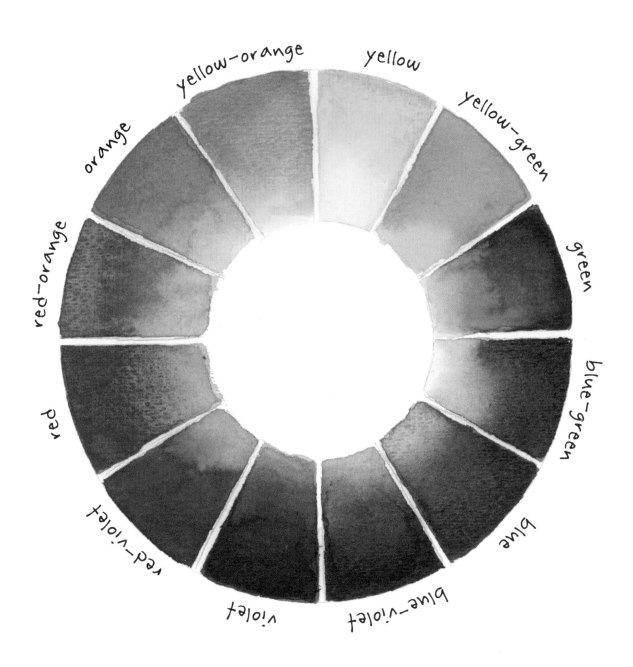

COLOR SCHEMES

MONOCHROMATIC: The painting of a raven on page 6 uses various values of one color: purple.

ANALAGOUS: This color scheme uses three to five colors that are next to each other on the color wheel. In this example, the colors center around yellow (yellow-green, yellow-orange, and yellow).

PRIMARY: These colors are equidistant from one another on the color wheel.

COMPLEMENTARY:

This color scheme features two colors directly across from each other on the color wheel, which maximizes contrast to catch the eye.

SPLIT COMPLEMENTARY:

Take the complementary scheme one step further. Starting with one color (blue), look across the wheel to find its complement (orange). Then choose the two colors on either side of the complement (yellow-orange and red-orange). These three colors make up the split-complementary example of a blue jay perched in an autumn maple.

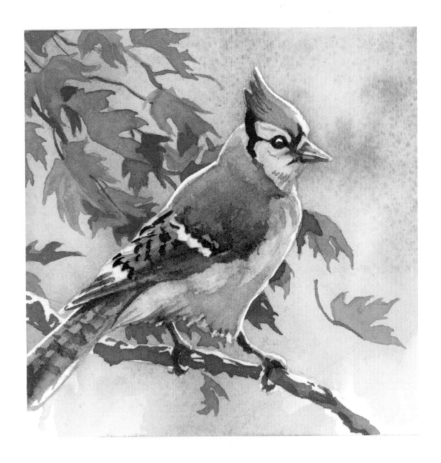

MORE ON COLOR SCHEMES

If you choose the three colors that are evenly spaced around the color wheel (green, violet, and orange), you have a triadic color scheme featuring a high contrast. If you paint entirely in shades of gray, you have chosen an achromatic color scheme.

SATURATED COLORS: These colors are closest to the pure versions on the color spectrum or, to the artist, the color wheel. The most saturated colors are the primary colors: red, blue, and yellow. In watercolor paint terms, cobalt blue, lemon yellow, and cadmium red are highly saturated primary colors.

UNSATURATED COLORS: These colors do not actually appear on the color wheel. Common examples include burnt sienna, indigo, and raw umber.

tip

 YOU DON'T NEED A PREMIXED BLACK PAINT FOR WATERCOLOR. COMBINING PRIMARY COLORS OR USING HEAVILY PIGMENTED CONCENTRATIONS OF DARK COLORS WILL ACHIEVE A BETTER RESULT.

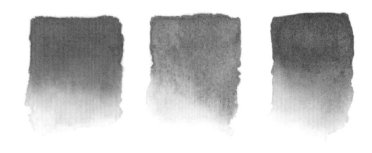

TRANSPARENT COLORS:

Transparency refers to a color's luminosity. When you paint with a highly transparent color, the white page or layers of paint underneath are more visible. Common examples of transparent colors include permanent rose, cobalt blue, and burnt umber.

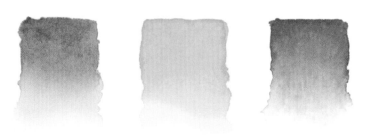

SEMI-TRANSPARENT COLORS:
Less light shines through these colors. Common examples of semi-transparent colors include sap green, gamboge, and raw umber.

OPAQUE COLORS:
These paints have little transparency and less luminosity. Thinning with water allows for a higher level of transparency, but opaque colors can lose their intensity. Common examples include sepia, cadmium red, and yellow ochre.

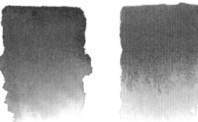

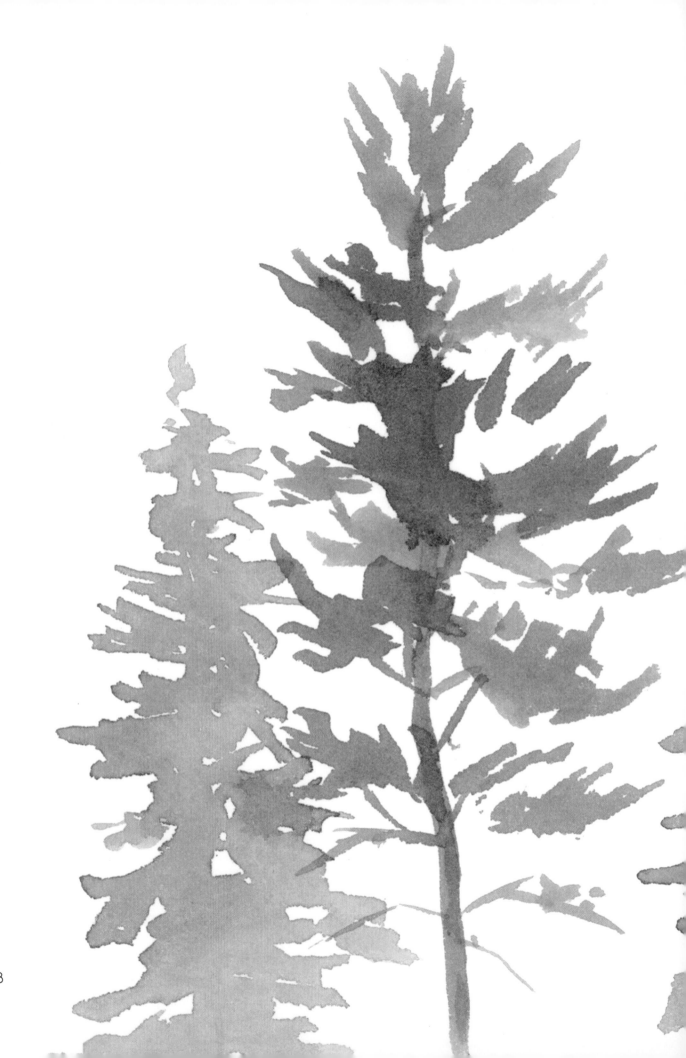

WORKING WITH Water

It's a Wash!

A wash is simply thin color that covers all or a large portion of your paper. What each wash looks like and how it is created will vary.

SINGLE-COLOR WASH: To create a solid, single-color wash without gradients or textures, start by mixing a puddle of paint. Fully saturate your brush, and with your paper and art board tilted at a slight downward angle, paint a horizontal line. Paint the next horizontal line just underneath and overlapping the first one. Continue until you have a flat block of color.

GRADED WASH: This transitions from concentrated to diluted color. A graded wash, which makes a good beginning to landscape paintings, can be used to paint the sky.

Begin by slightly tilting your art board and saturating a brush with paint. Make a horizontal brushstroke. Dip your brush in clean water, and wipe off the excess water. Now paint another horizontal brushstroke below the first one, slightly overlapping it. The color will begin to run downward. Repeat the last step. Each subsequent stroke will have less paint in it and the pigment will run downward, forming a seamless gradient.

TWO-COLOR VARIEGATED WASH:

You may want more than one color in your wash. For example, sunsets (see page 58) can feature different colors blending into each other. Combining two colors on a wet page and allowing them to mix is called a "variegated wash."

To create a simple two-color variegated wash, start by creating a graded wash following the steps on page 20. Then flip your art board upside down, and create another graded wash with a different color. Do this on a blank part of the paper and work downward, overlapping the first wash. The colors on the top and bottom of the page will remain pure, while the colors in the middle will blend.

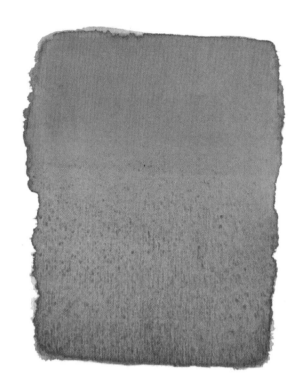

IRREGULAR VARIEGATED WASH: Not

all variegated washes have to be created in such a calculated fashion. For a more "painterly" experience with a large degree of variation and unpredictability, try making an irregular variegated wash.

Start by wetting the paper where your wash will go. Using a mop brush, paint one side of the paper, letting the pigment run and fade toward the center. Have fun with it: Dribble a little water on the paint, or place more pigment in some areas. Then tilt the art board around to let the colors run. To the left of this wash, add another color. Let the color mix with your previous wash.

IF YOUR PAPER IS *very wet,* THE COLORS WILL RUN FASTER AND BLEND MORE THOROUGHLY.

Go with a Glaze

Sometimes a wash doesn't look the way that you originally intended it to. Watercolors look darker while wet and lighten as they dry. You might find that a wash dried lighter than you wanted, or that the whole wash could benefit from a change in hue.

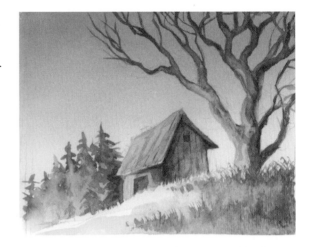

Enter the glaze. Glazing is the process of adding a thin layer of color over an existing wash or painting. By changing the hue, you can often change the entire mood of a painting.

In this little scene, an old wooden shed stands on a hill with a dead tree in front. I intended to make it an eerie scene, but the background wash above looks vibrant and cheerful.

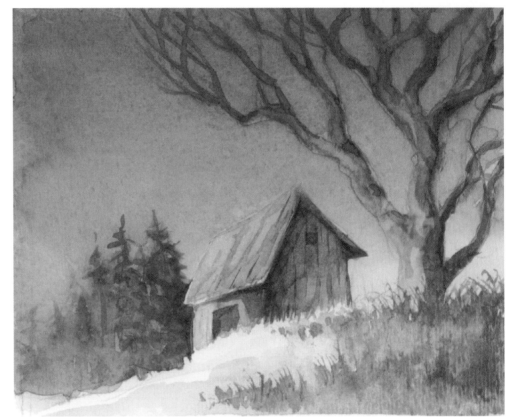

To alter this, I mix a watery puddle of paint and use my wash brush to paint a diluted uniform wash over the whole painting except for the shed and grassy foreground. The sky becomes moodier and more ominous, and the background trees and branches blur slightly. Now it looks less like a crisp dawn and more like a spooky old shed.

Pigment + Water

Using watercolor boils down to understanding one thing: how pigment and water interact with each other. The basic rule is that water will always flow toward less wet areas.

If you take a painted, semi-wet surface and add pure water, the water will disperse into the painted surface, creating water blossoms.

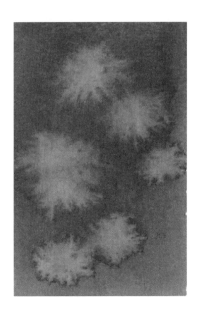

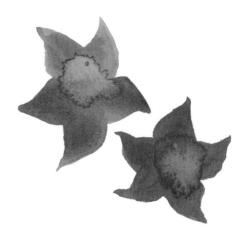

When this happens by accident, it can ruin a painting. But sometimes this texture can be used to create desirable effects like these flowers.

If your paint is dry or nearly dry and you drop water on the surface, it will not disperse as quickly, and most of it will evaporate. But it will still have an effect! When all is dry, a concentrated dot will mark the water spot. This is an easy way to create dewdrops. Just drop some water from a saturated brush, and then let the painting dry.

23

FADING OUT COLOR

Having established that wetness will move toward less wet areas, we can explore the concept of fading out color. Paint a circle of concentrated pigment with a saturated (very wet and paint-filled) brush. Now dampen the paper to the right of the dot with clean water, and keep wetting the paper until you brush the very edge of the dot. Notice how the pigment flows away from the saturated circle and into the damp area and creates a seamless fade from color to white paper.

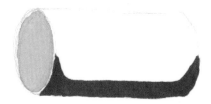

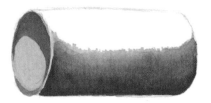

Now see if you can control it by making a simple shape. You might notice that this is the same principle used in the graded wash on page 20. By touching the edge of your pigment with a clean brush, the color flows until almost entirely diluted. The body of the hollow cylinder fades from the bottom up, and the inner shadow contained in the oval fades from the top down. You can create shading and three-dimensional shapes with this simple technique.

LIFTING OUT

There is another way to fade out color. The principle remains the same: You move the wet pigment to a less wet area. In this case, the less wet area is a balled-up paper towel. Notice the brown painted square below (left). While the paint is wet, press the paper towel into it, and lift. *Voilà!* A puffy dot of color has been removed (right).

Wet-on-Dry vs. Wet-into-Wet

Using water, the crucial element in watercolor painting, takes patience and the acceptance that sometimes an effect won't work out as intended. Try experimenting with the different techniques to see which works best for you.

Applying pigment directly to dry paper is called painting "wet-on-dry." It can be used to create minute details and hard edges. This is the easiest method to master and involves applying chosen colors to dry paper, allowing you to control shapes and boundaries to give you a clean, crisp painting.

Applying pigment to damp or wet paper is called painting "wet-into-wet." The edges of the paint dilute outward into the wet paper, creating soft edges. You will wet the paper thoroughly before painting. The water abstracts the shapes and blurs their edges, but you still get a sense of the subject matter and see some interesting combinations of color.

IT CAN BE TEMPTING TO PAINT ON DRY PAPER, LIKE YOU WOULD WITH ACRYLIC, BUT YOUR PAINTING MAY BENEFIT FROM PAINTING ON WET PAPER.

MASTERING WATER

WET-INTO-WET Wet the paper thoroughly before painting. The water abstracts the shapes and blurs their edges, but you can still get a sense of the subject matter and see some interesting combinations of color.

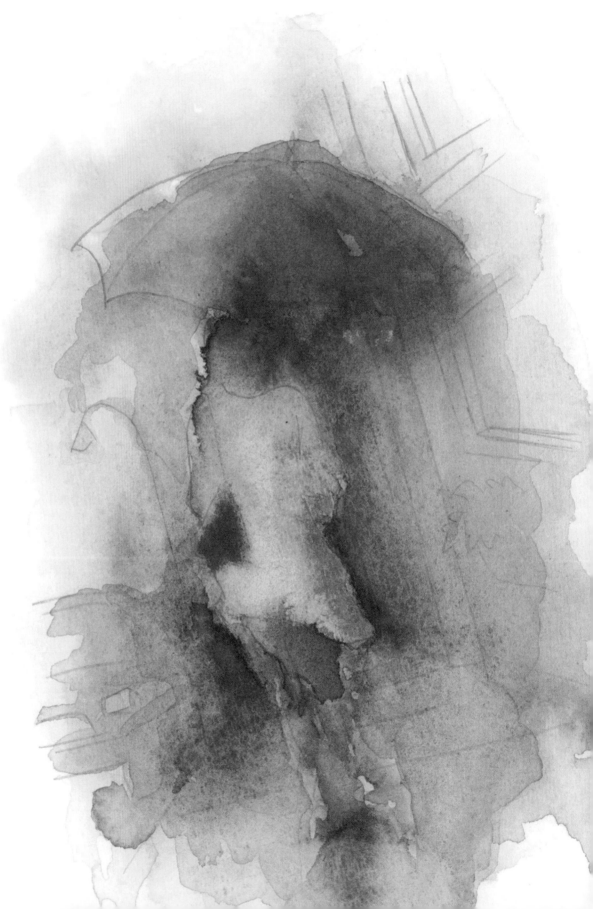

WET-ON-DRY This is the easiest method to master. You apply your chosen colors to dry paper and control shapes and boundaries for a clean, crisp appearance.

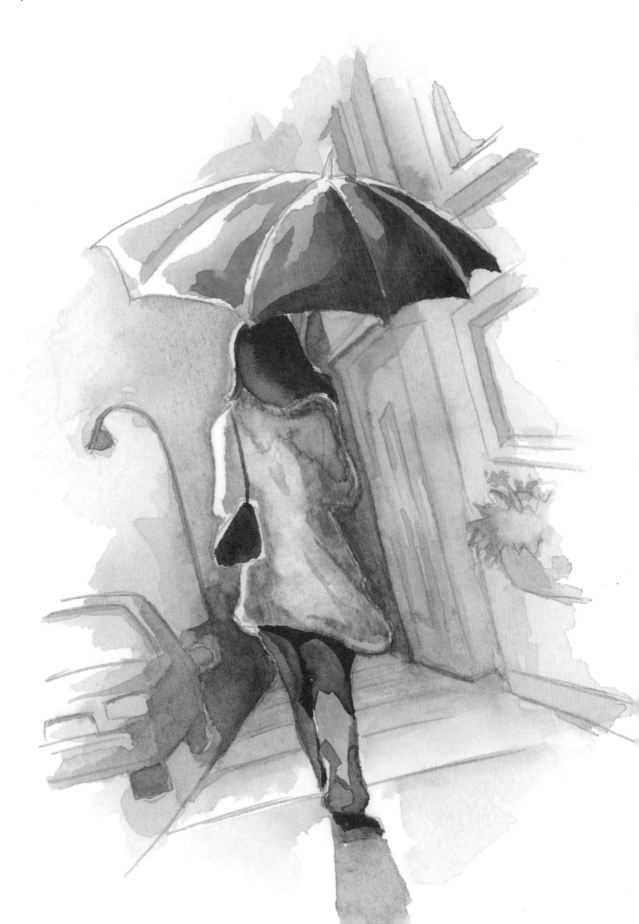

WET-INTO-PARTIAL-WET This example melds the two methods. The paper is wet when you paint the background colors, causing them to run together. Let the painting partially dry before continuing. Periodically dab clean water here and there to give some of the surface a wet area to blend into, like under the woman's foot and the edge of the umbrella. It has some of the spontaneity of wet-into-wet as well as some control from the wet-on-dry method, making the subject matter more recognizable.

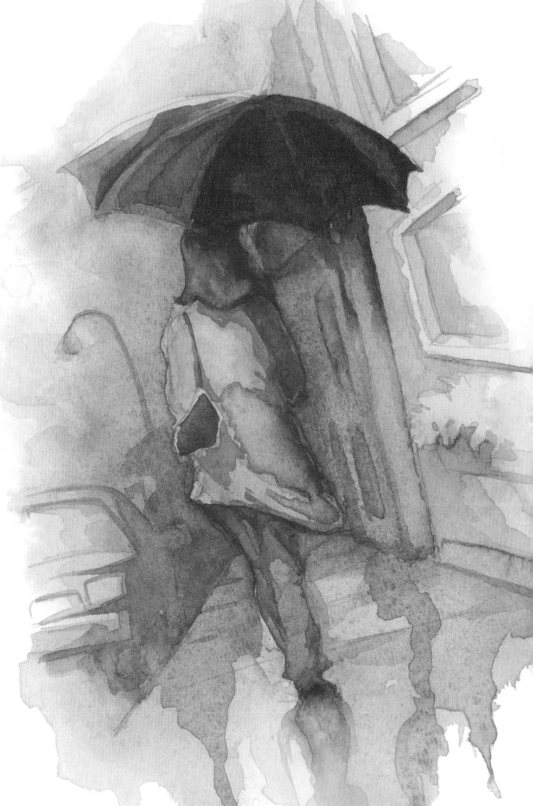

FIGURING OUT THE BALANCE BETWEEN THESE METHODS IS AN ONGOING *challenge* **FOR EVERY WATERCOLOR PAINTER.**

WET-INTO-WET
BACKGROUNDS

The entire background behind the fox starts out wet.

As the paper dries, darker greens suggest tree boughs.

The two layers of background from painting wet-into-wet build on each other.

The fox is painted last. Note the hard edges created by painting wet-on-dry.

The fox looks sharp, with the wet-into-partial-wet less in focus, and the wet-into-wet least in focus. This mimics how our eyes see the world.

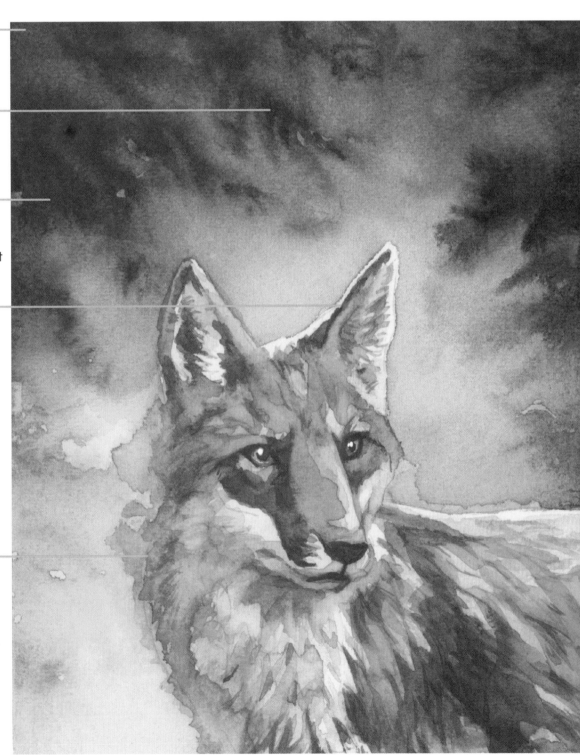

ADDING TEXTURE

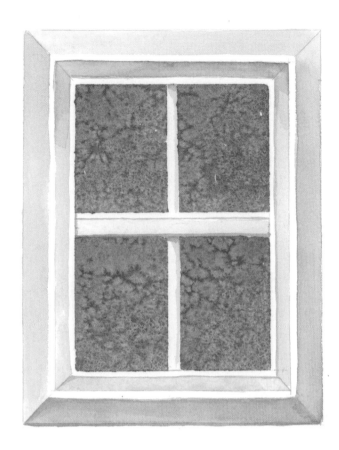

SALT: When you add salt to a painting, it bleaches the paint by drawing the pigment toward the crystals, producing feathered, naturalistic textures. Add salt when the page remains wet but not dripping. If you drop salt on a painting that is too wet or too dry, not much will happen. Here, dropping salt on a variegated wash (see page 21) creates a frost-covered window. Salt can also be used to create texture on a sandy beach.

tip

MODERATION IS KEY; EVEN JUST A FEW SALT CRYSTALS WILL MAKE A DRAMATIC DIFFERENCE.

SPRAY TECHNIQUE: A light spritz of water into color can also create unique and beautiful textures, as you see here. Notice the tiny dots of texture in the areas that were lightly watered versus the larger "blossoms" in the areas that were watered more heavily.

Here, a spritz of water creates not texture but a soft gradient. With the spray technique, you have limited control over water and paint, but it can create a wonderful sense of atmosphere.

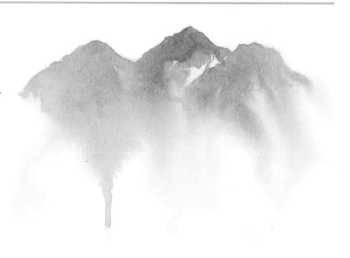

Master Spatter

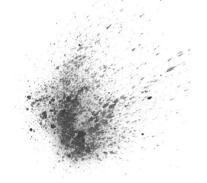

Run your finger along the paint-saturated bristles of an old toothbrush to spray the paint on your paper. This method produces a variety of dots.

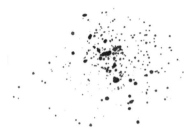

Saturate a brush with water and pigment. Then use the handle of another brush to tap the handle of the saturated brush, shaking loose dots of paint on the page. This method is easier to control, and the dots look less static and more uniform in shape.

Spattering PAINT CAN PROVIDE A PAINTING WITH MOTION AND ENERGY. DIFFERENT METHODS CAN CREATE DIFFERENT EFFECTS.

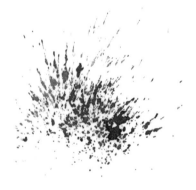

Run your finger along the bristles of a natural flat or fan brush saturated with paint to produce a variety of shapes and widely dispersed dots.

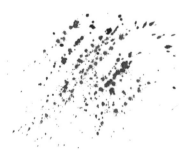

While it's possible to use a round brush for this method, the dots tend to disperse in a closer, more uniform pattern of rows.

Spray + Spatter

The spray and spatter techniques can also be used in tandem, creating an energetic, wild splashing. The foot here appears to be kicking the water rather than hovering above it. This technique can be used to create any subject, whether it's a fish, a frog, a bucket, or something else.

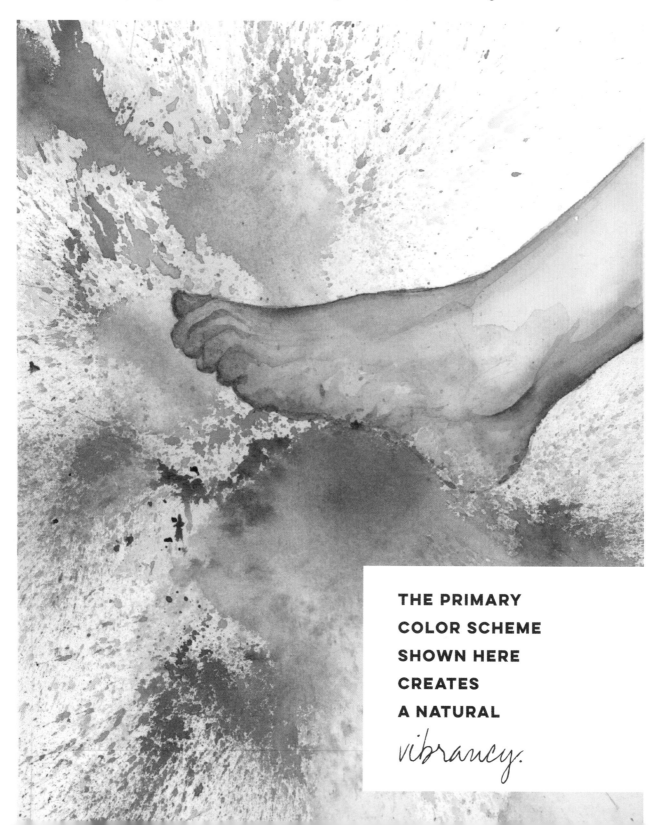

THE PRIMARY COLOR SCHEME SHOWN HERE CREATES A NATURAL *vibrancy.*

Positive vs. Negative Space

Understanding the difference between positive and negative space is absolutely crucial in watercolor. It opens up all kinds of possibilities for layering colors and forming compelling compositions. Positive space painting involves painting the form of the object or subject matter, and negative space painting means painting the area surrounding the form or subject matter.

Positive space

NEGATIVE SPACE PAINTING CAN BE USED TO DRAW ATTENTION TO THE MAIN SUBJECT, OR THE POSITIVE SPACE. IT CAN ALSO BRING *balance* **TO A WATERCOLOR PAINTING.**

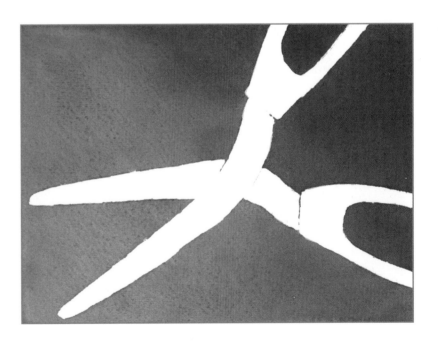

Negative space

33

CREATING DEPTH WITH NEGATIVE SPACE

Now try working with negative space. Start with a light, colorful variegated wash (page 21). Then draw the outline of a maple leaf. Repeat drawing leaf shapes and painting new washes around the leaves' borders several times. Some of the shapes peek out from behind other leaves, so they remain partially complete. In the final painting, you can see multiple layers of leaves bursting forth even though just the space around them is painted. The ones painted around first appear closest.

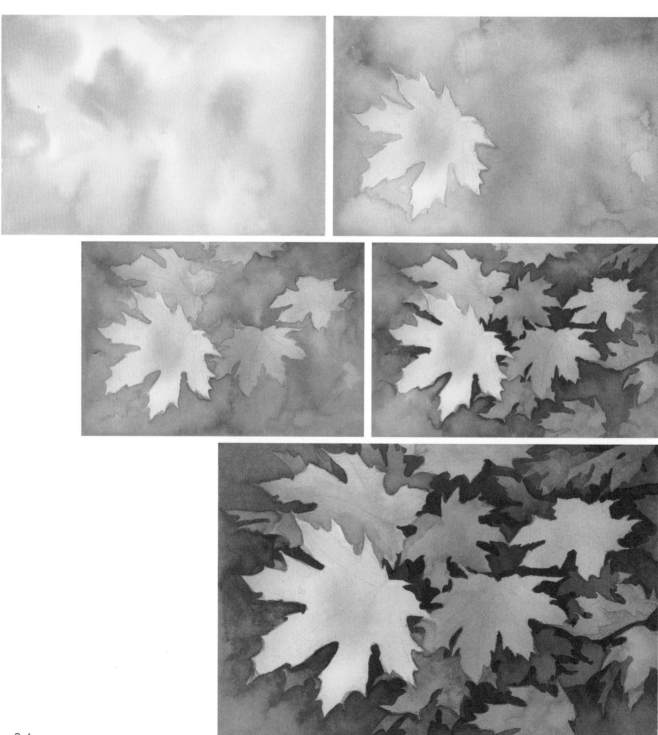

Negative Space & Masking Fluid

Masking fluid, a liquid latex that can be applied to paper, is another essential tool for watercolorists. When it dries, you can paint over it and preserve the white underneath. Removing it unveils a fresh surface to paint on. Use a rubber eraser or your thumb to brush off masking fluid.

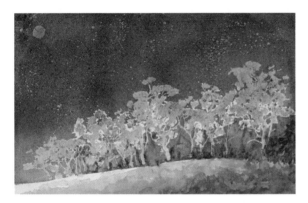

Masking fluid creates the stars, foliage, and moon in this nightscape. Use a palette knife to paint the branches and tree trunks connecting the foliage to the horizon. When the masking fluid is dry, create a wash over the sky, and mark a grassy hill.

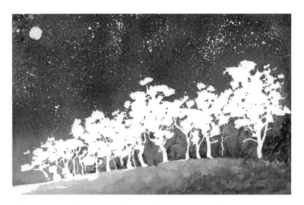

Remove the masking fluid once dry. Now you see a white silhouette of the trees, moon, and stars.

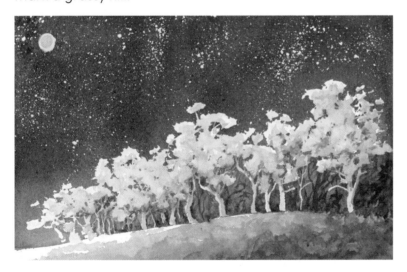

When your painting is nearly done, consider whether it needs details, such as the soft, eerie nighttime glow created here by adding yellow-greens and light blues.

tip

ONLY REMOVE MASKING FLUID ONCE IT IS COMPLETELY DRY. REMOVING MASKING FLUID WHILE THE PAGE IS STILL EVEN A BIT WET WILL TEAR THE PAPER.

PAINTING *Natural* FEATURES

The Elements That Make Up a Landscape

Now that you're familiar with many watercolor-painting techniques, let's take a look at some more specific ways to use them by painting natural subjects, such as landscapes and flowers.

GRASS

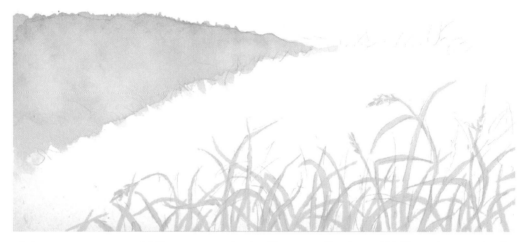

To paint a grass-covered hill, you can start with a gentle, far-off hill and grass in the foreground. Distant land tends to look lighter and closer in color to the sky, so choose a watery color that fades downward. Use a palette knife to add masking fluid for blades of grass.

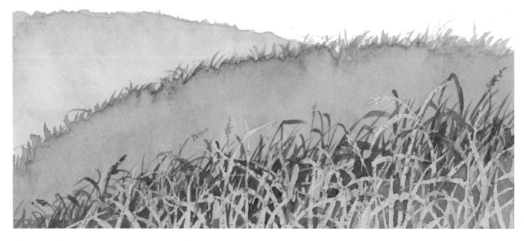

The darkest values go at the top of the hill. Irregular strokes swept upward give the hill a more defined grassy edge. A second layer of masking fluid at the bottom of the page creates blades of grass.

GRASS IS OFTEN OVERLOOKED, BUT IT PLAYS A LARGE ROLE IN *landscape* PAINTING.

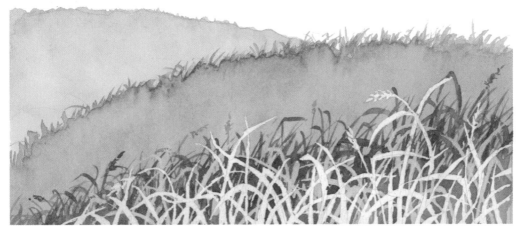

When all of the paint is dry, remove the masking fluid to reveal the grass.

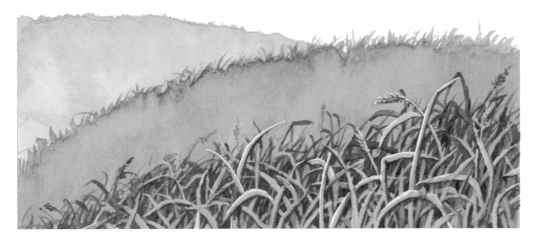

Add definition and details last, such as shaded edges between the blades of grass.

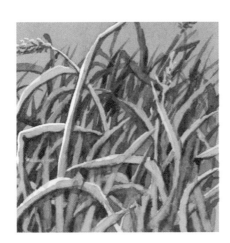

Leaving white highlights pops the grass into the foreground.

ROCKS

When painting rocks close-up, you can think of it as a positive-space experience. You are not tackling the space around the rocks; you are painting the rocks themselves.

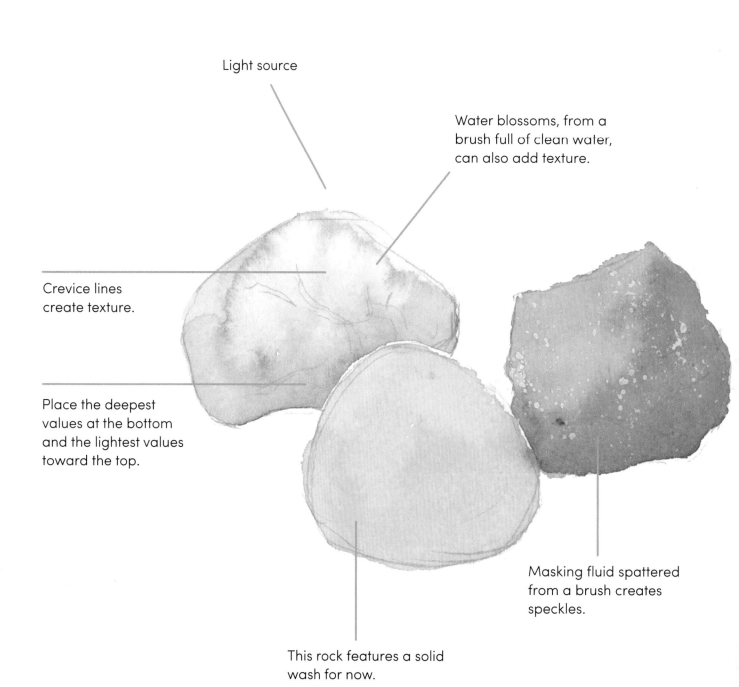

Light source

Water blossoms, from a brush full of clean water, can also add texture.

Crevice lines create texture.

Place the deepest values at the bottom and the lightest values toward the top.

Masking fluid spattered from a brush creates speckles.

This rock features a solid wash for now.

PAINTING WITH LESS WATER AND MORE PIGMENT MAKES THE DARK VALUES LOOK MORE PRONOUNCED.

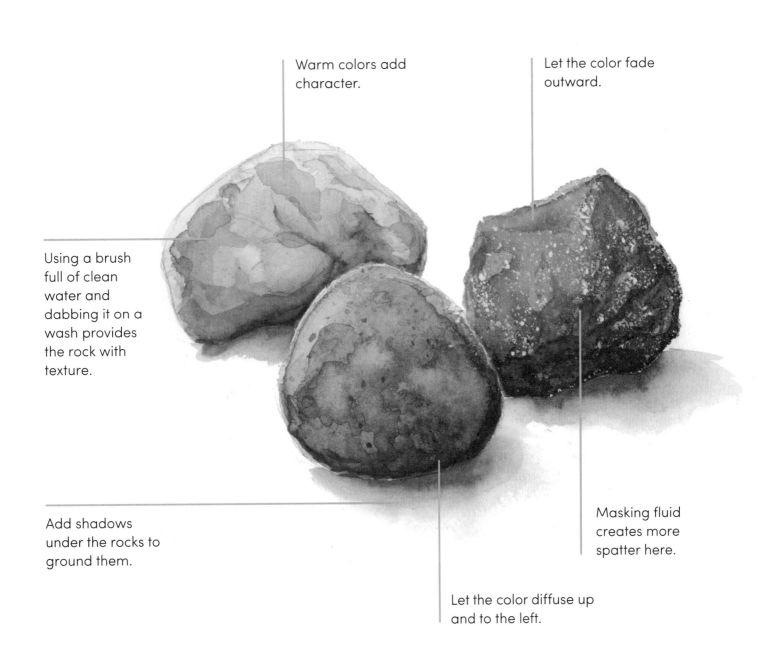

Warm colors add character.

Let the color fade outward.

Using a brush full of clean water and dabbing it on a wash provides the rock with texture.

Add shadows under the rocks to ground them.

Masking fluid creates more spatter here.

Let the color diffuse up and to the left.

A PILE OF BOULDERS

When painting large quantities of rocks, positive space painting can be time consuming and difficult, and you might end up losing that "loose" watercolor feeling. Negative space painting often works better.

A variegated wash captures the general values of the rocks, and salt tossed on top bleaches out some interesting textures.

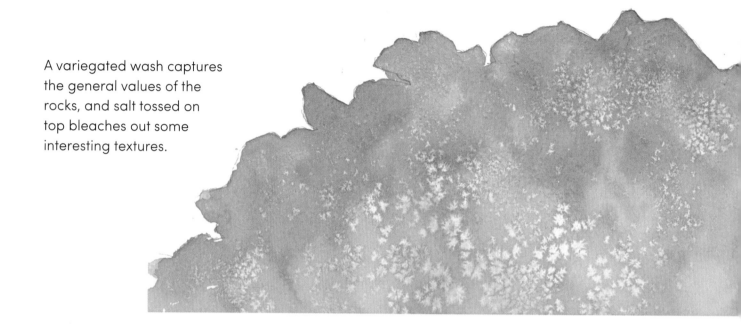

To create spaces between rocks, use darker colors and negative space painting. You can sketch the rocks in advance to help yourself envision the shadows and crevices.

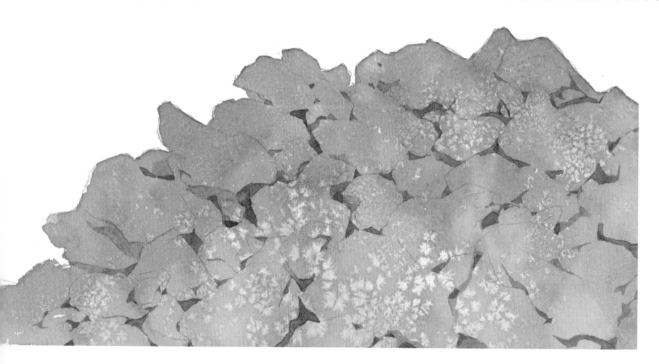

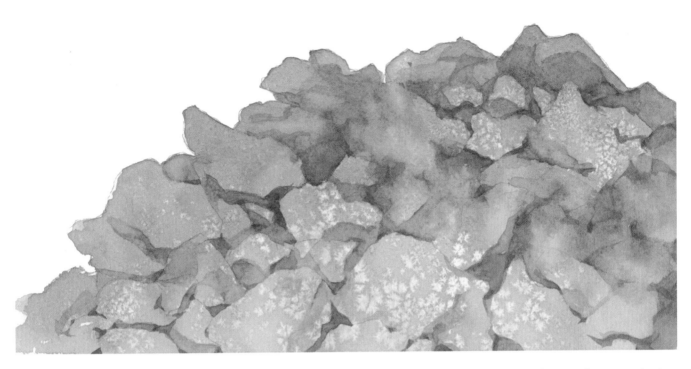

tip

FOR AN INTERESTING MIXTURE OF COLORS, TRY WETTING SOME AREAS FIRST USING A CLEAN BRUSH AND THEN PAINT WET-INTO-WET.

Introducing midtones that are darker than the initial wash but lighter than the colors between the rocks creates naturally flowing shadows of colors. Paint these midtones wet-into-wet.

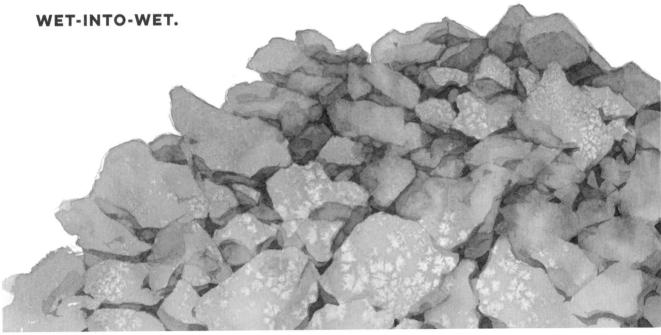

Negative space painting again works well for the smallest cracks and other dark shadows and shapes. This large pile of rocks now has light values from the initial wash, midtones, shadows, and cracks. The darkest shadows and cracks are added last. The colors and salt patterns give the rocks a natural irregularity.

43

COMBINING TIPS & TECHNIQUES

Now that we've explored some basic watercolor tools, techniques, and tips, let's see how they come together to create a finished painting of a pink lady's slipper.

Painting wet-into-wet helps you avoid hard edges.

Masking fluid creates the white highlights on the stems, petals, and leaves' small edges.

To create gradients inside the leaves and along their veins, paint a brushstroke of color, and then run a clean, damp brush along the color to fade it outward.

Use damp paper towel to lift out some pigment and keep the edges faded.

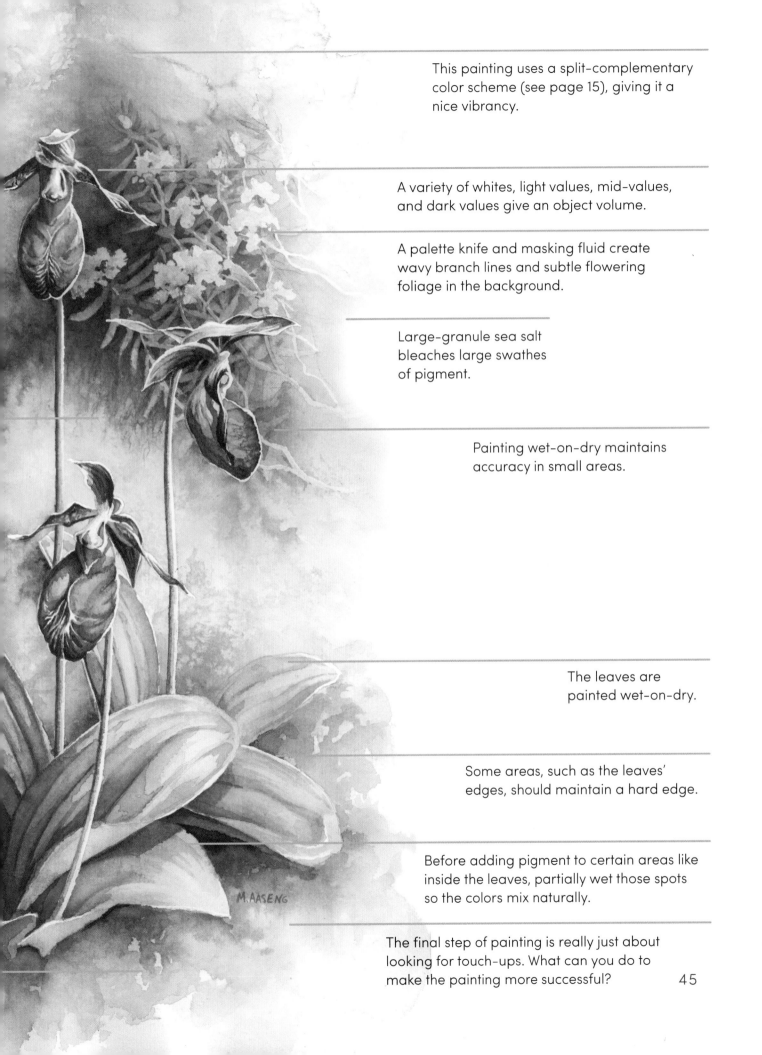

This painting uses a split-complementary color scheme (see page 15), giving it a nice vibrancy.

A variety of whites, light values, mid-values, and dark values give an object volume.

A palette knife and masking fluid create wavy branch lines and subtle flowering foliage in the background.

Large-granule sea salt bleaches large swathes of pigment.

Painting wet-on-dry maintains accuracy in small areas.

The leaves are painted wet-on-dry.

Some areas, such as the leaves' edges, should maintain a hard edge.

Before adding pigment to certain areas like inside the leaves, partially wet those spots so the colors mix naturally.

The final step of painting is really just about looking for touch-ups. What can you do to make the painting more successful?

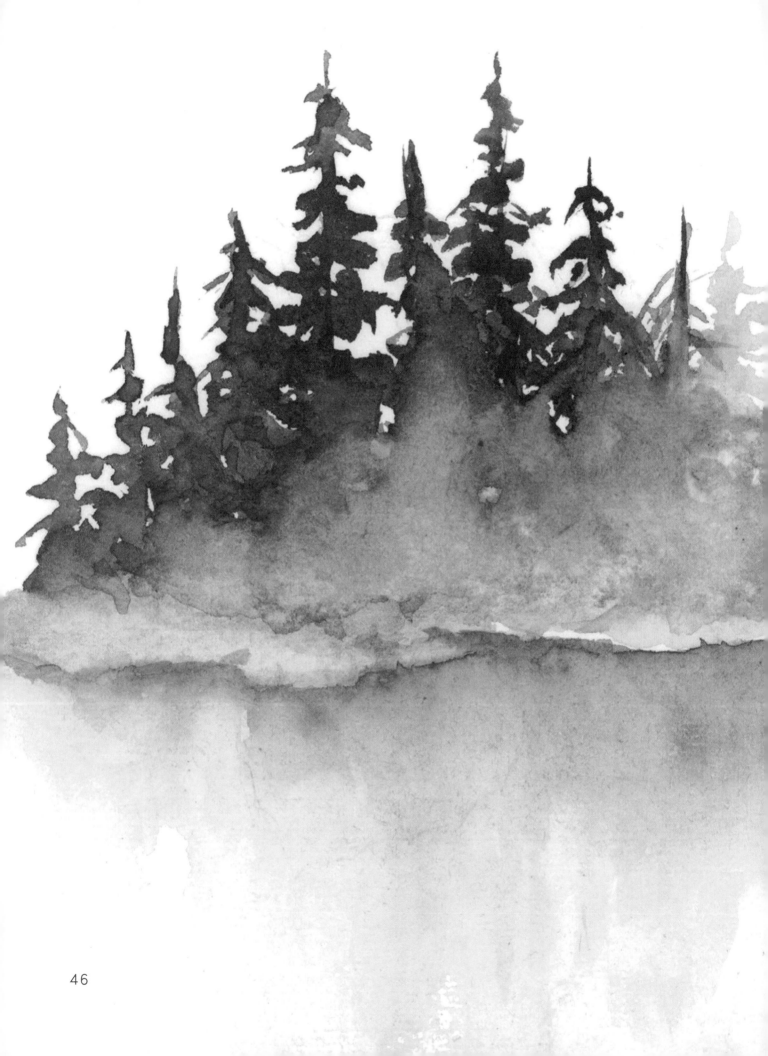

BRINGING *Landscapes* TO LIFE

Starting with Trees

Trees play an integral role in landscapes. They come in myriad shapes and can be painted in many ways, so it helps to practice painting several different types.

PINE TREE: A simple approach to painting a pine is to begin with a light color for the foliage and then add darker values for the shadows and woody sections.

AN ANGLED BRUSH WILL ACHIEVE A VARIETY OF EDGES AND SHAPES.

Using the wet-on-dry technique (see page 25), quickly paint in upward sweeping shapes to form the tree boughs. Before the paint dries, touch a darker shade to the bottom of these shapes. The pigment will bleed upward and form naturally shadowed foliage. Now add an even darker value to the bottom of the boughs.

Finally, paint behind and between the existing boughs to connect them. Dilute the woody color with water when you map out the branches and trunk, and add more pigment to create a darker shade for shadows. Make sure the foliage paint is dry, so the browns don't bleed into the greens.

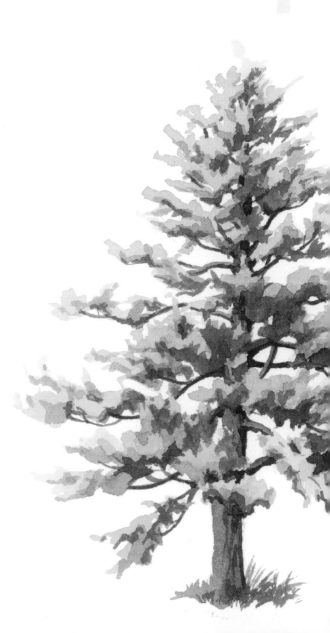

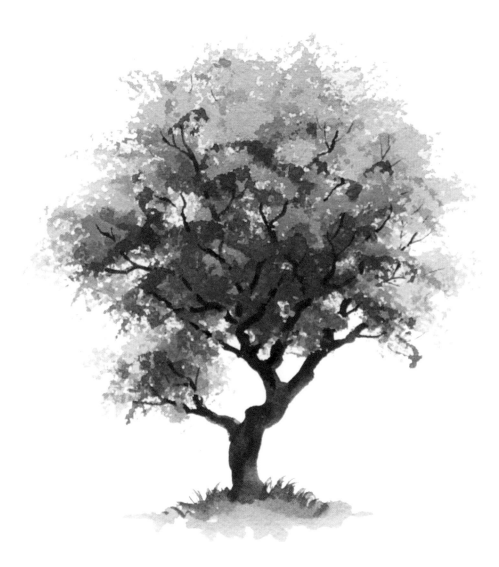

SPONGE OAK: To paint a tree simply and quickly, use a sponge! Repeat the steps for painting a pine tree, increasing the darkness of the paint between steps. Allow the paper to dry between layers of paint so the colors lay on top of each other rather than bleeding into each other. Add a tree trunk using a round brush, and then ground the tree by painting a small patch of earth below.

WHEN PAINTING WITH A SPONGE, THE SPONGE SHOULD BE MOIST BUT NOT DRIPPING. YOU CAN DIP THE SPONGE IN A PUDDLE OF PAINT, OR PAINT ON THE SPONGE USING A BRUSH. THEN DAB THE SPONGE ON THE PAPER.

USING A VARIEGATED WASH

Using a flat, synthetic brush, twist and flick to create light-colored, jagged-edged palm fronds. While the paint remains very wet, dip your brush in a deeper shade, and continue painting jagged edges. Paint quickly, switching between the two colors and letting them blend.

Once the paper is dry, do the same thing again within the palm fronds. Notice the midtones as they mix. For a variety of values, make sure some of the initial wash appears. Now extend the color downward to form a trunk and, using the same loose motion, create a shadow below.

DETERMINE THE LIGHT DIRECTION BEFORE ADDING HIGHLIGHTS OR SHADOWS TO A PAINTING.

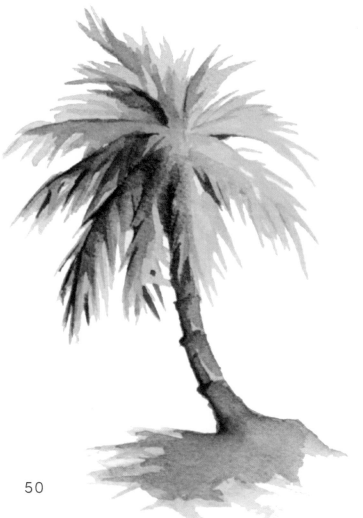

Make your darks darker, and extend them into the trunk to create ridges. Touch some lighter color to the bottom of the tree trunk, and add a layer of value to the shadow below the tree, forming a soft variegated wash. Add lighter color to the light side of the trunk to provide color contrast to the shadowed side and to indicate light reflecting off the bark.

IMPRESSIONISTIC EVERGREEN: To maximize the benefits of painting in watercolor, let the water and pigment create visual interest. Working from the top down and using an angled brush, paint the general shape of an evergreen tree. Trees aren't symmetrical, so flick your brush erratically to create its form without details. Moving downward, switch to lighter colors to create a variegated wash. Near the bottom of the tree, touch the edge of the paint with a clean, wet brush. The pigment from the tree will blend downward.

Once the wash is dry, paint broken sections of trunk in the middle of the tree to create overlapping boughs. At the bottom of the tree, run a curved line of paint intersecting with the trunk. To fade the color downward, touch the tree with a clean, wet brush.

EVEN FROM THE BEGINNING, THIS TREE CONTAINS VERY FEW DETAILS. THIS HELPS CREATE AN ALMOST DREAMLIKE EFFECT.

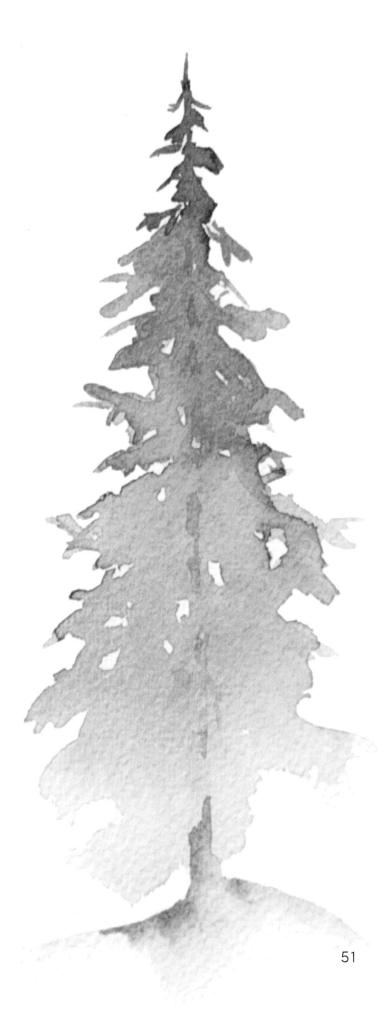

CREATING MOOD

A painting's mood is often dictated by lighting choice. From sunshine to shadows, there are lots of variations. Let's try painting a tree that is backlit by the setting sun.

First make a quick drawing, including irregular shapes for gaps in the leaves and branches. Then create a wash with the lightest values in the center and the darkest values radiating outward. Once dry, apply masking fluid to the gaps.

Paint the silhouette of a tree. Painting the entire tree in one color and adding another color in the center while the first remains wet creates a dark center and a glowing outer edge.

Now dip a small brush in clean water. Dab the areas toward the edges of the branches, and pull the brush toward the edge of the paper. Between each stroke, dip the brush in water, and work around the tree. This pulls the dried pigment outward to mimic the effect of light shining around the tree.

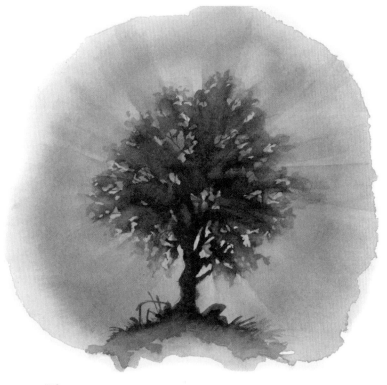

Let the paper dry, and remove the masking fluid. Wet a brush, and pull pigment to the edge. Now start your brushstroke outward from the areas where the masking fluid was, keeping some hard edges. Add tiny branches inside the gaps left by the masking fluid. This helps the mind make sense of the tree's random gaps and connects the leaves to the trunk.

FORMING BRANCHES

Trees are not always distant objects. Let's take a quick look at how to create a few up-close branch details.

To paint a standard branch supporting big shady leaves, you will again layer colors from light to dark. Leave gaps between the leaves in some areas, and create a shape with points on the bottom edge and rounded curves on the top to mimic how a leaf hangs on a branch. Remember to break off and continue branches behind leaves to create the illusion of bushiness and depth.

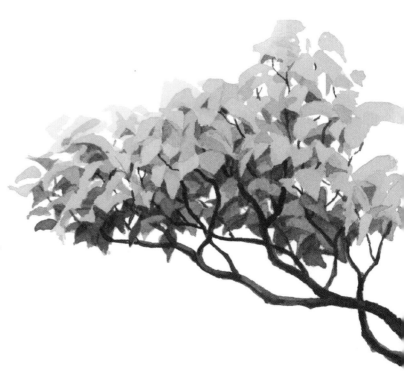

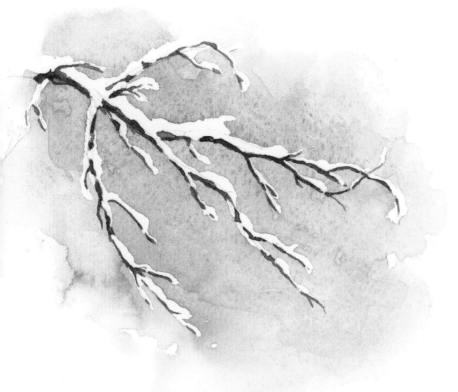

To create a snow-covered branch, first draw its outline. Apply masking fluid everywhere you would like to show snow clinging to the stems. The beauty of this simple approach is that the paper creates the most pivotal aspect of the painting: the snow! Then paint a background wash, and remove the masking fluid. Finally, use a liner brush or palette knife to paint the parts of the branch that peek out from under the snow.

tip

A RANGE OF COLOR CAN PROVIDE VIBRANCY TO YOUR SUBJECT MATTER.

SPRUCE NEEDLES: Painting evergreen trees up-close can seem daunting because of their countless needles, but it's not that difficult! Start by drawing the shapes of the spruce needle clumps, and then wet the paper. Paint a streak in the middle of each needle clump shape, and then dab in streaks of darker pigment beneath and between the shapes. Let the colors diffuse.

Now paint silhouettes of branches. Negative space paint the closer branches, and paint the farther-back branches more solidly. Give the foreground branches a little detail—but not so much that you cover up the light background color. Sweep shadows into the areas where the needles overlap. Also create shadows on the pinecone's cylindrical shape.

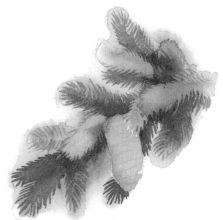

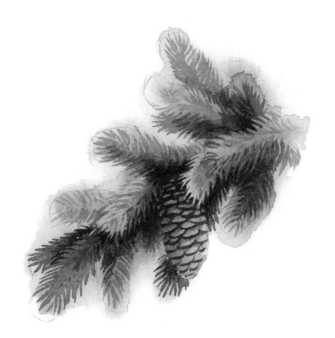

Using dark pigment, refine the lines on some of the needles. To give them more volume, you can paint the center of some of the needle clumps with a lighter shade. With a small, flat brush, negative space paint around the scales of the pinecone.

WHEN PAINTING WET-INTO-WET, YOU DON'T WANT YOUR PAPER DROWNING IN PUDDLES OR PATCHY WITH DRY AND WET AREAS. AN EVEN COATING IS BEST.

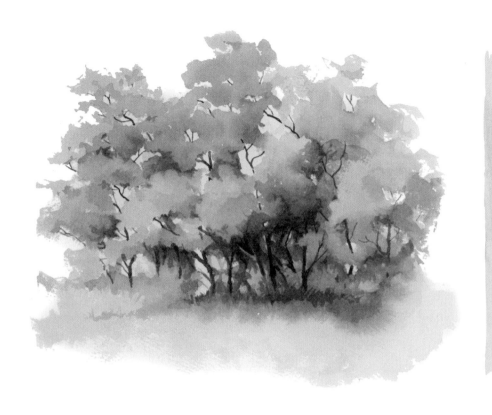

THE VIEWER'S MIND USES *sparse* DETAILS AS CLUES TO READ THE IMAGE AS A TREE GROVE, SO YOU DON'T HAVE TO PAINT EVERY TREE.

GROUPING TREES TOGETHER

To create a group of trees, you don't need to paint each tree individually. The method is very similar to painting the pine tree on page 48. First create irregular patterns using a lighter and a darker pigment. Let the colors mingle.

Repeat the process (light color, dark color, repeat), moving over a larger area of the page. Allow varying sizes of gaps to show. Continue until you complete the canopy, making sure the darker colors are at the bottom.

Wet the area beneath with a watery coat of paint. Paint a streak of concentrated paint at the top of this light, wet coat, and let that color diffuse outward. This serves as the grass and the shadow cast by the trees on the grass.

Now paint the details using the wet-on-dry technique. Adding just hints of structure, paint the lines of branches, some pointed edges on the undergrowth, and a few deeper shadows between the tree canopy and the grass layer.

tip

 AIM FOR A VARIETY OF SHAPES AND SHADES.

MASTERING THE SKY

Watercolors are arguably better suited to painting skies than any other landscape feature. By practicing different methods, you might be surprised by the results you can achieve! You can paint a sky without clouds, such as with a graded wash, but you will eventually need to paint clouds. There are many approaches to these ephemeral structures, and I'll touch on two.

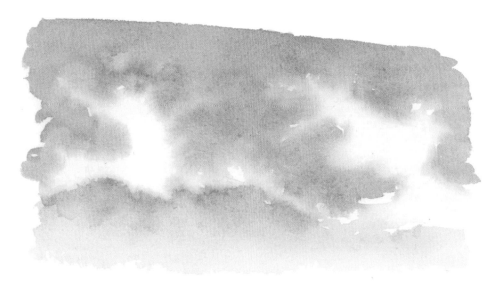

CLOUDS WITH SOFT EDGES:
You can create their blurry-edge effect by wetting an area larger than you actually want the cloud to be. Paint the sky in negative space around the clouds, and let the paint touch the wet area. The pigment will spread into the clouds.

CLOUDS WITH HARD EDGES:
Create these by leaving the paper dry when you paint the sky around a cloud shape. This technique is useful for creating big, billowy clouds with more distinct shapes.

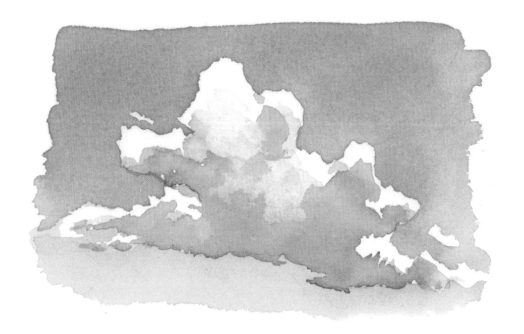

PAPER-TOWEL TECHNIQUE

Begin with a wet page. Fold two paper towels to form compact squares. Now load your brush with blue, and paint horizontally across the page. Apply more concentrated paint at the top, and add more water to the mixture toward the bottom. Allow the blues to run downward by tilting your art board.

 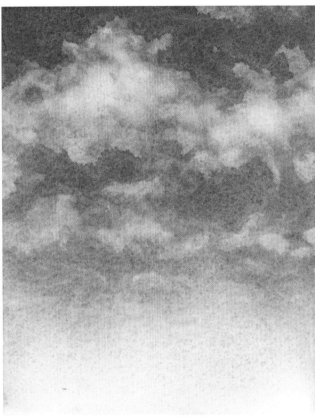

Let the water run, and then use the folded paper towel to dab areas of the paper and lift up. Fold and refold the towel so you always press a clean edge into the wet paint, and work quickly to remove the blue pigment and create cloud shapes.

Now try creating larger and thicker clouds. As you get closer to the bottom of the blue wash, start wiping the towel horizontally to make streaklike clouds. This mimics what you see in nature.

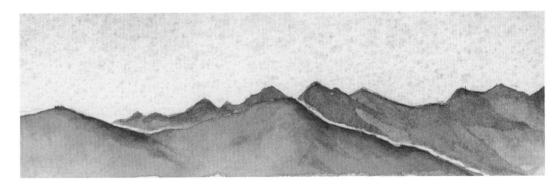

Adding a landform can make a painting a complete landscape. Up-close areas hold contrasting colors.

57

PAINTING A SUNSET WET-INTO-WET

On a prewetted page, use a large flat brush loaded with pigment to create three rows of color: blue, red, and yellow. Make sure you include a buffer of paper between each color; the paper's wetness will cause the paint to run and mix. If you paint the areas too close together, they will mix too thoroughly.

Let your paper dry partially. Running a small brush between the colors mixes them and creates shades of purple in the transition zone, giving the sky a cloudy texture. The colors flow together and mix to create an ethereal effect.

FOR A *sunset,* ANY BLUE, RED, AND YELLOW COLORS WILL DO.

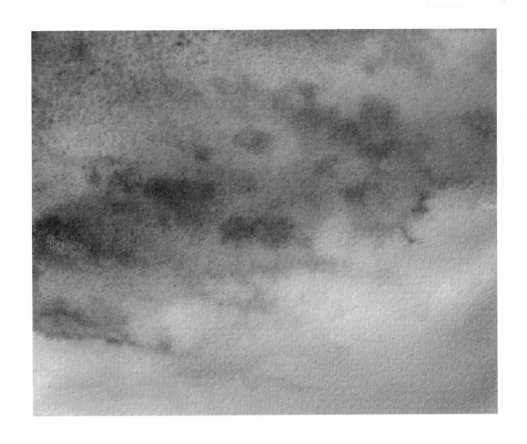

A PAINTING MAY NOT LOOK FINISHED YET, BUT TRY TO STOP BEFORE YOU THINK YOU SHOULD. LET THE COLORS MINGLE AND DRY ON THE PAPER.

Remember our variegated wash from page 21? Here you're just adding a third color to paint a sunset.

FORMING A FOREBODING SKY

Start by wetting your paper and creating a graded wash. While the paper is still wet, add irregular horizontal shapes streaking across the sky. Use more pigment at the top, and add more water to the puddle at the bottom to fade the color. This creates a brooding sky.

Allow the paper to dry somewhat, so water no longer flows as quickly across the page. Paint cloudy streaks across the sky, moving the brush to create irregular and broken edges. Maintain the darkest clouds at the top and the lightest at the bottom.

Now use a paper towel to lift out some areas of pigment, creating softer edges and contrasting values of lights and darks among the clouds. If you notice any hard edges, use a brush and clean water to smooth them out.

SOMETIMES A LITTLE FOREGROUND SUBJECT MATTER CAN HELP *complete* **THE MOOD.**

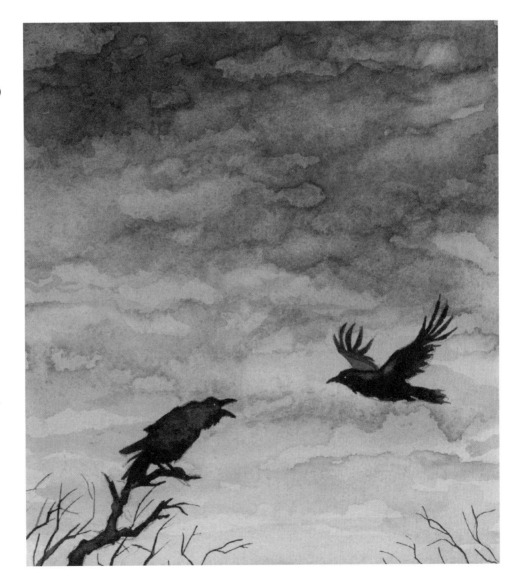

ADDING ATMOSPHERE

To paint convincing landscape scenes, you'll need to recognize the importance of atmosphere. Focusing on how objects appear in a variety of circumstances (in the distance, in the fog, in a reflection, in full sun, and so on) allows you to create a wealth of visual illusions.

THE FARTHER AWAY AN OBJECT IS, THE MORE IT CAN SHARE THE SAME COLOR AS THE SKY.

tip

 IT IS OFTEN BEST TO START WITH THE OBJECTS IN THE DISTANCE AND CONTINUE TO MOVE CLOSER. TO CREATE THE ILLUSION OF DISTANCE, WORK FROM LIGHT TO DARK.

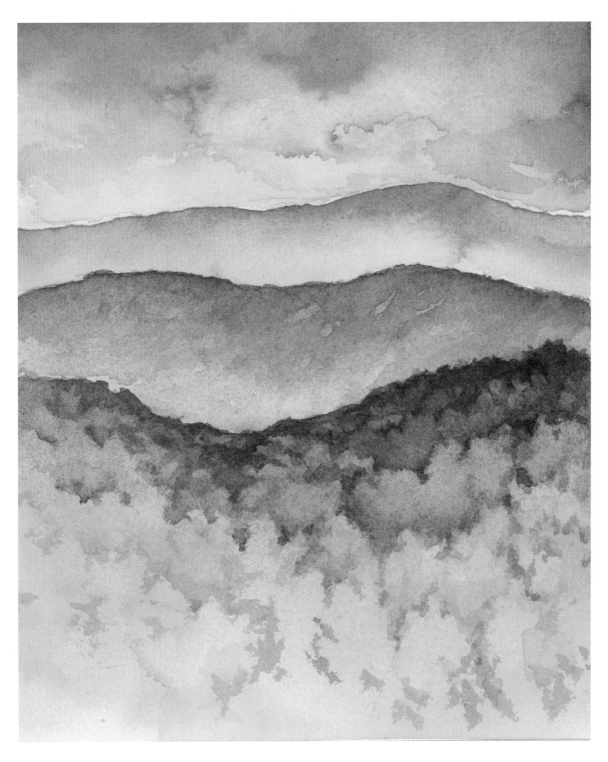

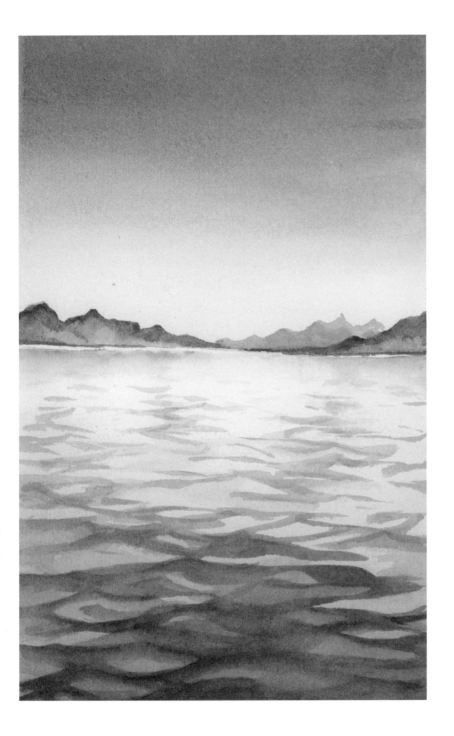

Painting water is often just a matter of painting the sky's reflection. Start with a variegated wash, and then flip the paper upside down, and paint a second one to mirror the first. Then paint darker patterns starting at the bottom of the paper and moving upward, diluting the paint as you work. Leave the shapes increasingly open as you work upward until you have only hints of light brushstrokes. Fade the hard edges at the bottom of your brushstrokes by using a damp brush to pull pigment downward.

ADDING LAND GIVES THE EYE SOMETHING TO GRAVITATE TOWARD. DISTANT ITEMS SHOULD BE LESS DETAILED AND CAN TAKE ON SOME OF THE SKY'S COLORS.

COMBINING TECHNIQUES TO CREATE A MOODY LAKESCAPE

To paint a dark, reflective painting, use techniques such as using masking fluid and creating midtones and a variegated wash. Starting with light values, add deeper shadows, and sprinkle salt to create texture.

To create texture in the sky, add clean water to softly bleach out some areas, and dab in more concentrated colors using very small brushes to add edges to the clouds.

Add your darkest colors to the tree edges to give them definition with little hints of light hitting the upper boughs.

Maintain consistency with your light source by painting lighter values on objects that face the sun, like the branches, and darker values underneath and opposite.

Start with light values, and work in deeper shadows.

The distant shoreline needs only minimal detail.

Horizontal lines suggest subtle ripples in the water and reflect the trees' dark colors.

Masking fluid creates the sun's reflection in the water.

Drop pinches of salt on the beach.

Work from light to dark.

The beach anchors the painting. Heavily pigmented darks provide contrast to the water and sky.

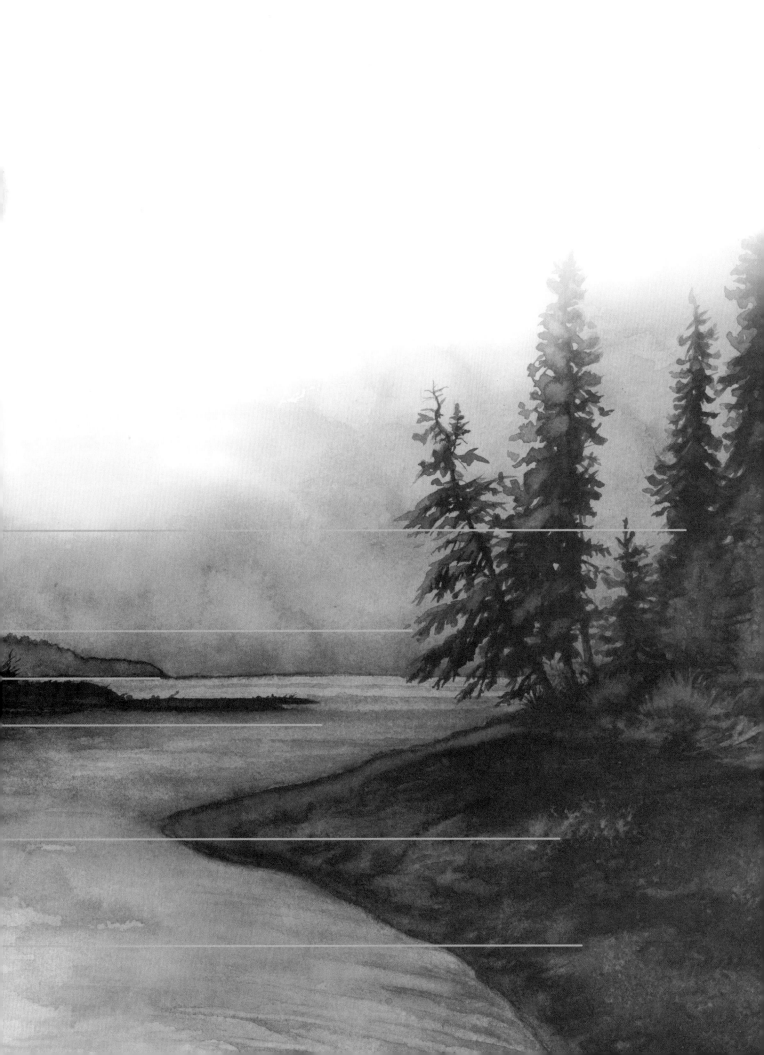

MOVING TO Man-Made STRUCTURES

Shapes + Shades

The previous sections of this book focused on natural subjects such as landscapes and their elements. Now let's move on to something entirely unnatural but still essential to watercolor paintings: man-made structures.

It can be helpful to think geometrically when painting buildings. They are usually composed of basic shapes, so if you can paint a cube or a pyramid, you're already on your way to creating a building.

BRICK BY BRICK

This brick building consists of a large cube with a rectangular column on top for the chimney. After drawing the shapes, consider the direction of the light and the affect on shading. Notice the differences in shading here, and apply these rules when painting all kinds of buildings.

Light source

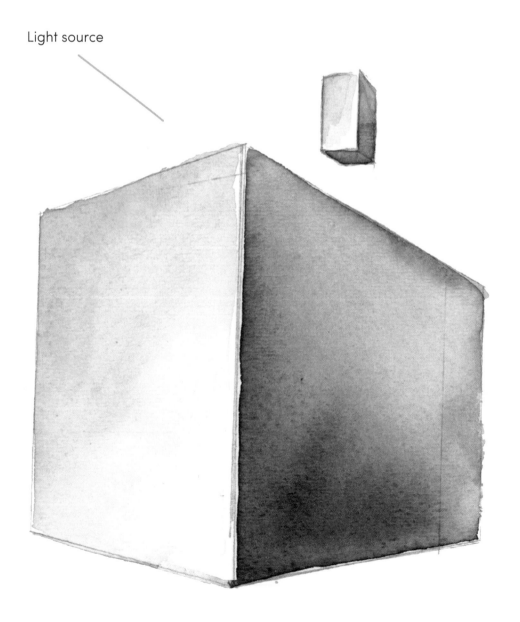

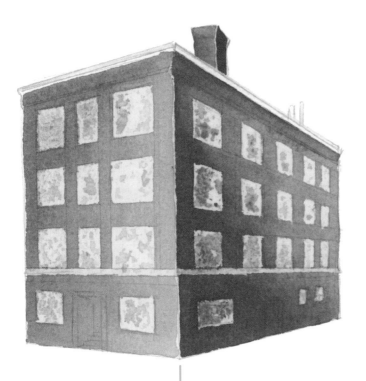

To paint a building, first draw its complete outline using a pencil. Then apply masking fluid over any white edges and all of the windows. Consider the light and shading discussed on page 70, and add the deepest, darkest colors to the bottom-left corner of the right wall of the building, lightening as you move up and to the right. Use the same paint for the left wall of the building, but dilute it with water to create lighter shades.

Give the structure definition by creating contrast.

Peel away the masking fluid, and then add details, such as the window frames and building's entrances, using a small flat brush. A dark mixture of paint creates the chimney's brick texture.

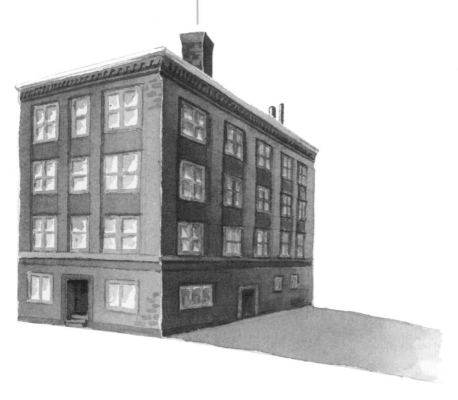

To paint the glass windows, add color using a small, angular brush, leaving some white to hint at a reflection. (The windows on the shaded wall should look darker.) Create subtle contrasts underneath the windows and on the walls, and negative space paint shadows on the molding to create texture. Paint the building's shadow using a variegated wash.

71

SUBURBAN HOME

The brick building on pages 70-71 provides a simple example of the basic shapes that make up a building. The same principal applies to other buildings that appear more complex, such as this large suburban house. Always separate the structure into basic shapes, and create values using light direction. This will give you a reference to use when painting the house.

Light source

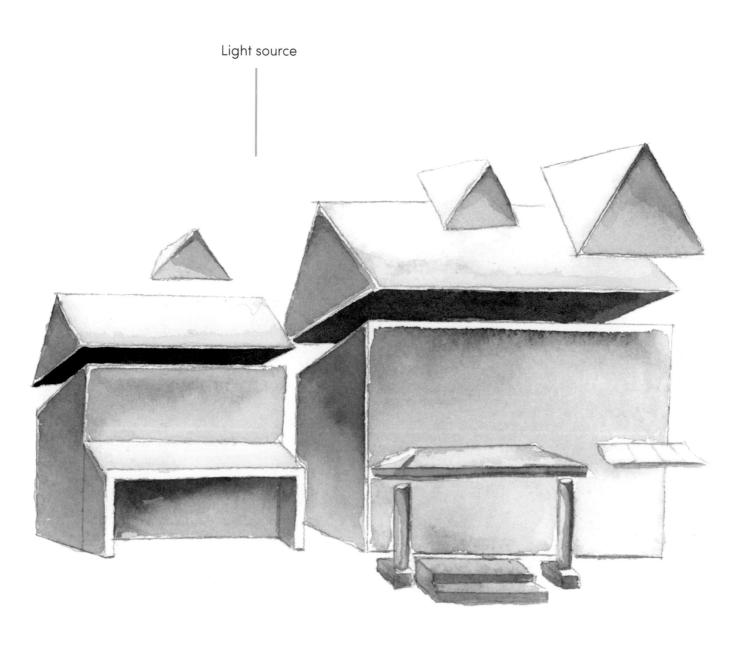

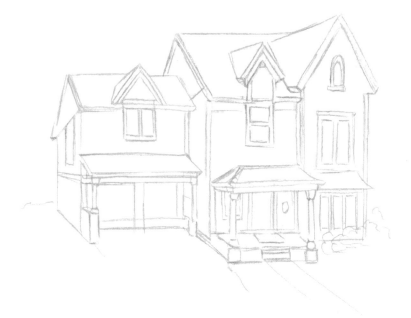

Start with a light pencil drawing. You can use a ruler for the long edges and freehand the smaller details, such as the house's columns, windows, and bushes.

ADDING TOO MUCH DETAIL CAN MAKE YOUR WATERCOLOR LOOK OVERWORKED. LET THE WHITE PAPER PEEK OUT IN SOME SPOTS. REMEMBER THAT WATERCOLOR OFTEN WORKS BEST FOR CREATING IMPRESSIONS INSTEAD OF CAPTURING ALL OF THE DETAILS THAT A PHOTOGRAPH MIGHT.

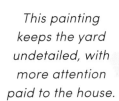

This painting keeps the yard undetailed, with more attention paid to the house.

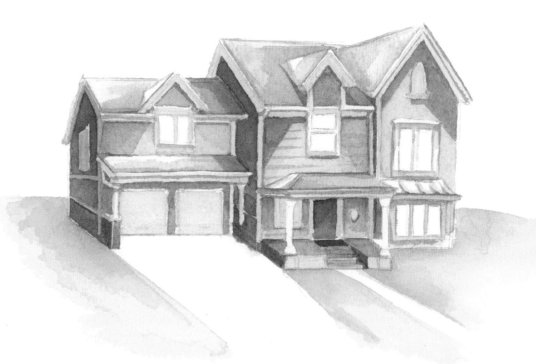

WORKING WITH MORE COMPLEX SHAPES

Simple washes of color establish values.

AN ANGLED BRUSH WORKS WELL FOR SHARP EDGES. THE POINTED TIP IS GREAT FOR TIGHT AREAS, AND THE FLAT EDGE HELPS MAINTAIN *crisp borders.*

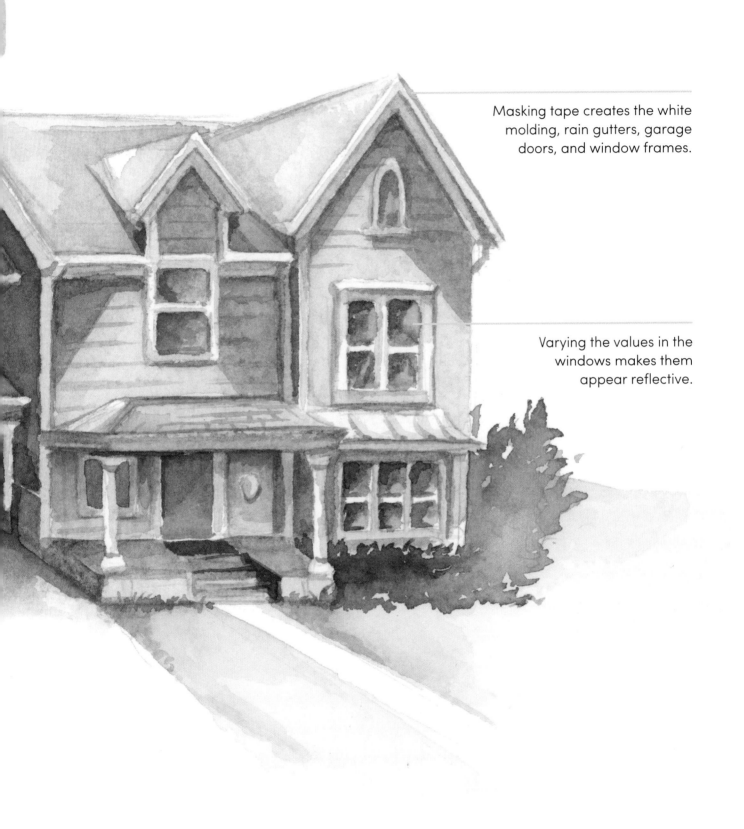

Masking tape creates the white molding, rain gutters, garage doors, and window frames.

Varying the values in the windows makes them appear reflective.

Setting the Scene: Urban Subjects

There are so many different features of the diverse, packed urban setting that characterize the human landscape, including skylines, bridges, and cars. Try combining these elements into one painting. Focusing on each element separately will make the painting more approachable.

1 CITY SKYLINE

Use a variegated wash to cover all of the buildings. If the light comes from the left, the top left of each building will feature one color for the sun's reflection, and the wash extending down to the right will be darker. Dropping water on the still-wet wash creates water blossoms as well as visual interest.

Painting this building using just one color makes it pop out from the rest and gives the city three-dimensionality.

To create three-dimensionality in the buildings, use more pigment to paint over their shadowed sections. Stay in the same color family, but vary the shades a little to create diversity.

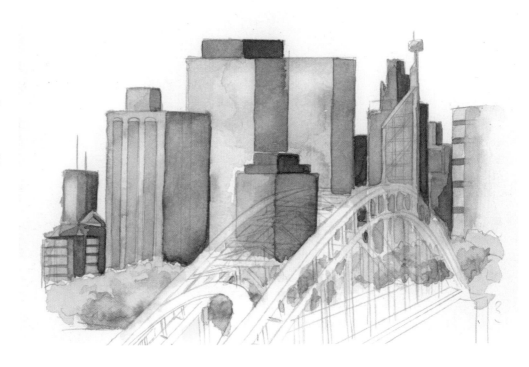

NOTICE HOW SKYSCRAPERS *are formed* **FROM BASIC RECTANGULAR BLOCKS.**

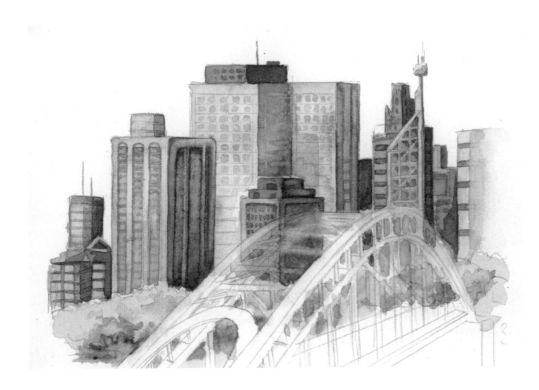

Switch to a very small, round, pointed brush to add details, such as the windows. The buildings shouldn't compete with the bridge, so dip an angled brush in clean water, and wipe the areas of the bridge that overlap with the skyline. Then sop up the paint with paper towel, leaving a ghosted shape.

2 BRIDGE

By adding masking fluid to the areas between the bridge's support bars and struts, you'll save yourself a lot of time later. This enables you to paint loosely without having to worry about avoiding tiny gaps.

Paint the receding part of the bridge with darker values. Add water to the same mixture to paint the foreground of the bridge. A streak of blue creates the shadow cast on the left side of the road.

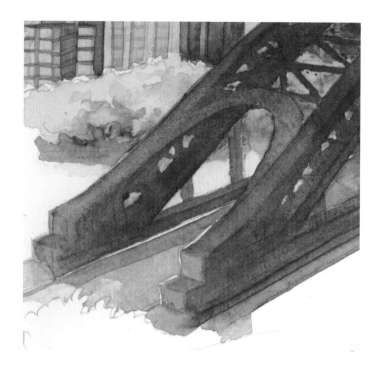

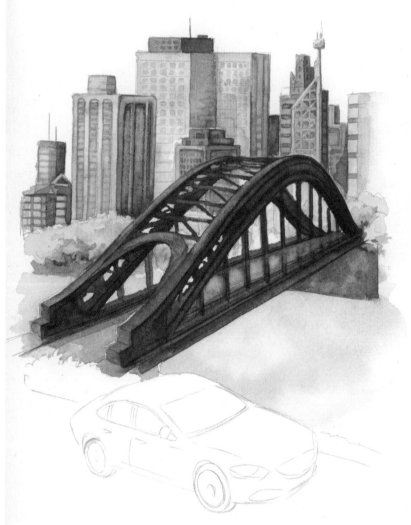

Deepening the dark values further defines the bridge's form. Add elements such as shadows and highlights to create contrast. Then peel away the masking fluid.

Use a tiny pointed brush to add even darker values to capture the bridge's details and textures. Negative space paint around the iron features that should stand out, such as the bridge's railings and triangular structures. Create lighter areas and soft highlights by wiping clean water over existing paint. Use a medium round brush to add the shadow of the bridge.

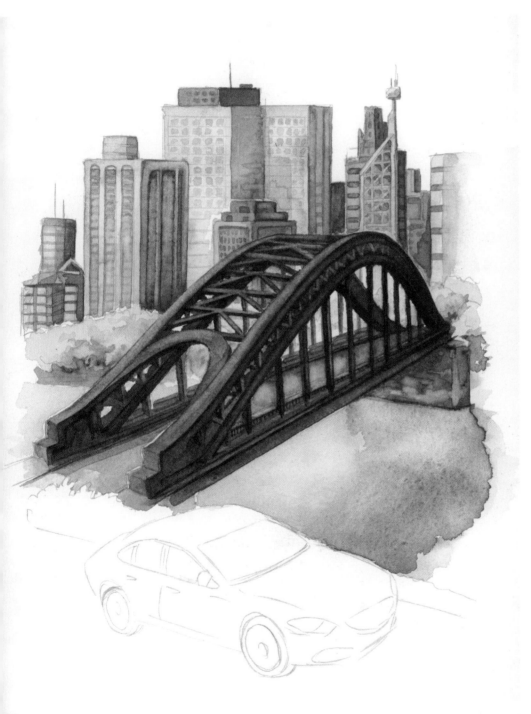

LAYERS OF LIGHTER, MORE DILUTED COLORS IN JUXTAPOSITION WITH DARKER, MORE *concentrated* **COLORS HELP ESTABLISH THE ILLUSION OF SPACE. THE BOLDER BRIDGE APPEARS CLOSER THAN THE BACKGROUND BUILDINGS.**

3 CAR

First apply masking fluid to areas that should stay white, such as the car's passenger windows, the headlights, and areas that need a reflection. Use a variegated wash to paint the car itself.

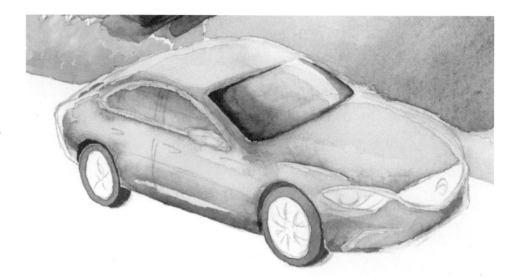

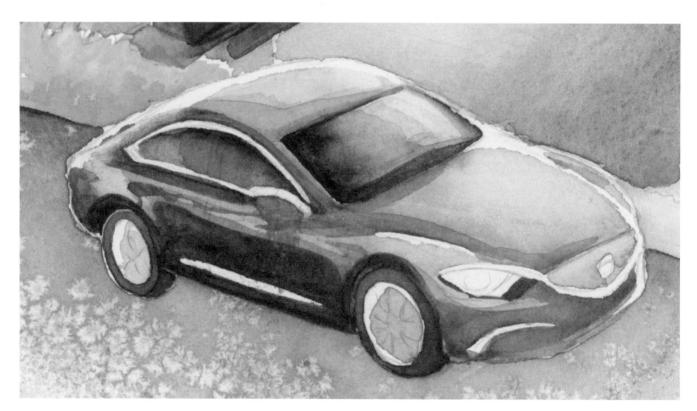

Deepen the shadows and create reflective shapes with darker colors. Removing the masking fluid reveals white reflections on the rest of the car. Paint a variegated wash for the road underneath the car, and sprinkle salt on the still-drying wash to create texture in the road.

ADDING YELLOW TO YOUR PAINTS CAN CREATE INTERESTING, *warmer* **HUES.**

THE *contrast* **OF EXTREME LIGHT AND DARK VALUES, SEEN IN THE VEGETATION AND THE LIGHTS AND DARKS OF THE CAR AND ROAD, MAKES THE FOREGROUND POP OUT.**

Add the deepest values to the car to give it a more finished shape. The car's interior and hubcaps can have an impressionistic look. Add the car's shadow to ground it, and then add other details, such as vegetation.

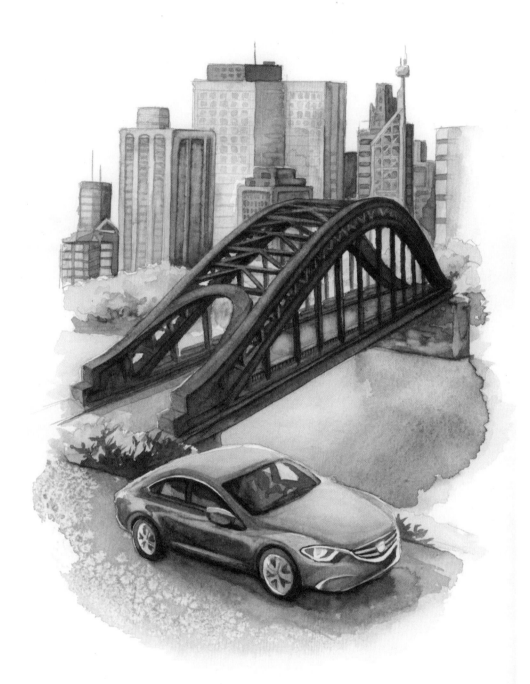

THE SKYLINE, THE BRIDGE, OR THE CAR COULD SERVE AS THE INDIVIDUAL SUBJECT MATTER FOR A PAINTING. BUT NOW YOU SEE HOW TO COMBINE MULTIPLE FEATURES BY *working in layers* **FROM BACKGROUND TO FOREGROUND.**

BUILDING ON THE
Body

Handling Hands

Now we'll move from man-made structures to the elements that make up human bodies, such as hands and faces.

MONOCHROMATIC HAND: POSITIVE SPACE PAINTED

Painting the entire area of the hand using positive space painting makes it stand out from the white paper behind it. You can use a pointed round brush to apply paint to the entire hand shape, adding clean water at the wrist to fade the color there.

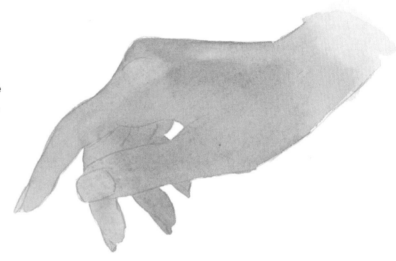

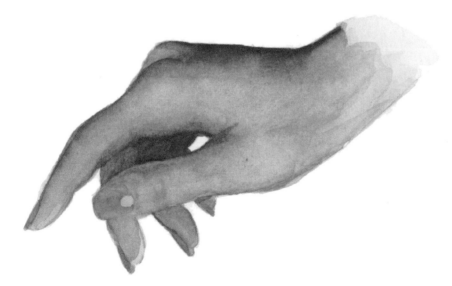

Apply a deeper value all over the hand except where you want the lightest values to show. Skin is soft and hands have subtle shading, so you want to get rid of any hard edges. To blend, dip the brush in water, dab it lightly on a paper towel, and run the brush along the edges, creating natural, faded-out shades on the skin.

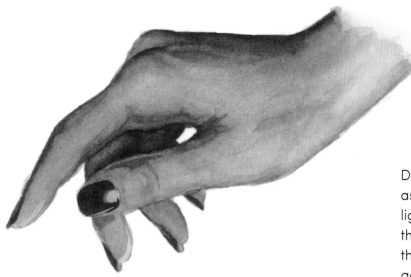

Darken the values more than once, as the shading on the thumb is lighter than the deepest values on the fingernails. By gradually working through a range of values, you can add volume to the hand, making it look more three-dimensional.

tip

BEFORE TRYING TO CAPTURE THE VARIETY OF SHADES AND COLORS FOUND IN SKIN TONES, PRACTICE USING ONE COLOR OR A MIXTURE OF COLORS. THIS ALLOWS YOU TO FOCUS ON BUILDING UP A RANGE OF VALUES WITHOUT BEING DISTRACTED BY COLOR POSSIBILITIES.

MORE ON MONOCHROMATICS: NEGATIVE SPACE PAINTING THE HAND

Another approach to painting hands is to activate the space around the hand shape, and then add detail to the shape. To do so, draw a hand, cover it in masking fluid, and then paint a wet-into-wet wash behind it.

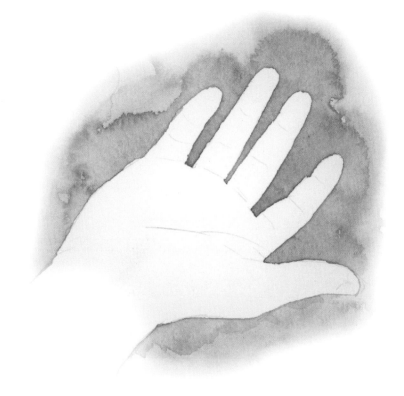

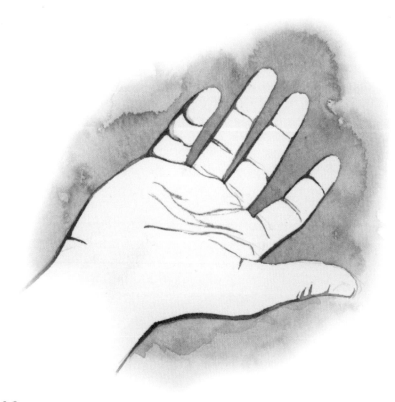

Now reverse a standard rule of watercolor, and work from dark to light. Use a liner brush to paint dark edges on the hand and lines in the palm and between the knuckles. Instead of tracing the entire hand in one bold line, leave some of the edges white.

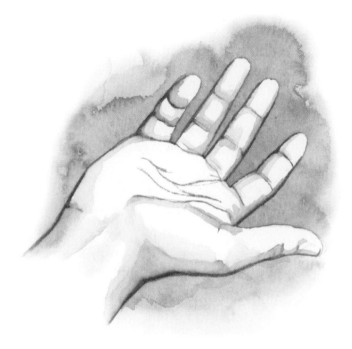

Apply midtones using a round brush. A brush with clean water can fade the edges in some places, such as the underside of the thumb.

Add the lightest values to the hand to fade some edges, and leave white space to create reflective highlights on the skin. Apply more pigment to the areas where you want to boost shadows, such as around the wrist and the pinky. If the paper is still wet, the dark color will bleed softly. In contrast, when the paper is dry, adding a dark band creates a hard edge.

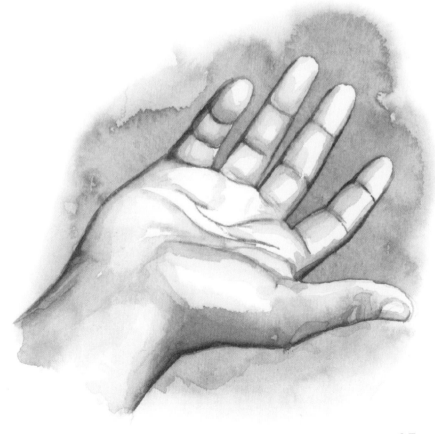

EYES & EARS: EXERCISES IN FACIAL FEATURES

You can paint accurate facial features with watercolor using some simple techniques. Let's take a look at two examples.

GET TO KNOW THE NOSE

FLAT WASH: Mix a puddle of pigment to use as your basic skin tone, and paint the entire nose area using a flat wash.

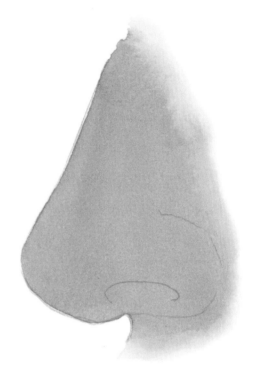

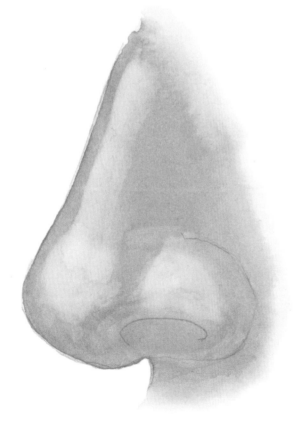

COLOR LIFTING: Allow the paint to dry a little, so it's damp, not soaking wet. Then press a paper towel or tissue to the areas of the nose with the lightest values, or highlights. These are often the most bulbous parts, such as the bridge and nostril.

WET-INTO-WET & FADING: To create shadows on the nose, add darker colors. With a clean, damp brush, wet the areas that need shadow. While they're damp, paint over them with darker pigment, allowing the colors to flow on the wet paper. This creates soft edges.

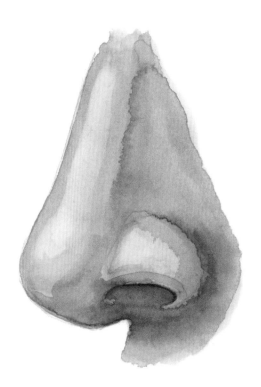

To create contrast on the inner nostril, wait until the paper is completely dry. Then paint the outside top and sides of the nostril with a dark but different color using a small round brush. Run a damp brush along the nostril line to fade the color down from the hard edge toward the shadow on the bottom of the nose and top of the lip. The edge looks hard around the nostril, but where you fade it downward, it blends with the rest of the skin.

ALL EYES ON YOU

MASKING FLUID & WASH: Apply masking fluid to the reflective spot on the eye, to the tear duct, and along a small line marking the bottom eyelid. Once dry, mix up a skin color. Use a large brush to paint this color in a flat wash all around the eye. Then partially clean your brush in water, and run your damp brush along the border of your first wash, causing the pigment to run and fade outward.

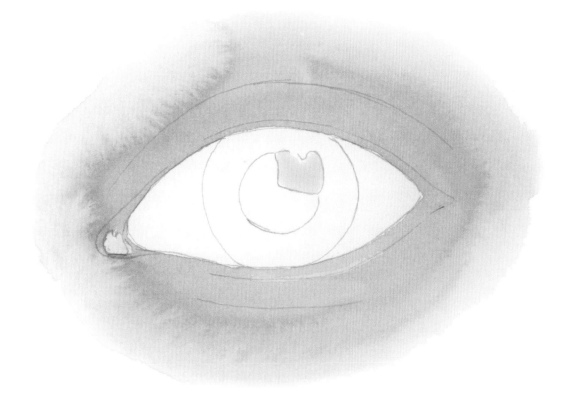

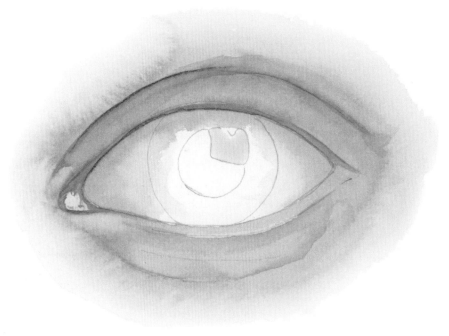

FADING: With an angled brush, paint a darker skin tone along the edge of the eyelids and in the tear duct, and add shadows. From the dark line of the upper eyelid, notice that the shadow falls toward the left side of eye and fades upward toward the right side. Use a damp brush to fade the shadows. Darken the areas under the eye where necessary.

To create the shading in the white of the eye, mix a darker color that looks similar to the skin tone. Paint this color along the top and side borders of the eye, and dampen your brush to fade it inward, leaving the bottom-center of the eye white.

WET-INTO-WET: Paint the iris and pupil of the eye using one color. While the paint remains wet, touch a small brush wet with clean water to the wash. This allows water blossoms to form and creates ethereal textures in the iris. When the paint is partially dry, brush in a darker color along the top and around the sides, narrowing as you paint downward. This creates the beginning of a shadow cast by the upper eyelid.

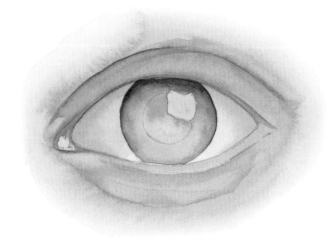

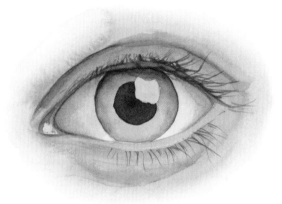

MIXING BLACK & LINER BRUSHSTROKES: When the iris color is dry, paint the pupil as a flat wash. Don't use black paint from a tube; it looks flat when it dries. Instead, mix your own.

Use a liner brush to create wispy eyelashes, starting the brushstroke where the eyelash attaches to the skin and ending with a flick at the outer tip. If the eyelashes look too detailed, run a damp brush along the edge of the upper eyelid to blur the colors.

MIX COLORS LIKE *sepia* **AND** *indigo* **TO CREATE A RICH BLACK.**

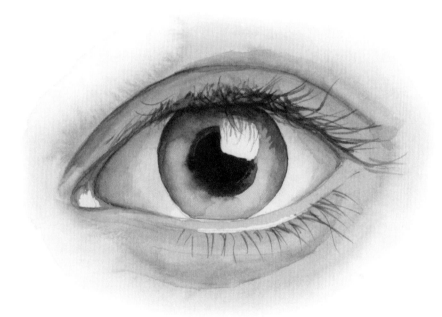

HIGHLIGHTS & LAYERS: Remove the masking fluid, revealing the white highlights. Then add the final details to the inner eye. Add a darker tone to the sides and bottom of the blue iris, and fade them inward with a watery brush. With a liner brush, sweep some of the darker tone into the white highlight to create the reflection from the eyelashes.

Add a deeper black to the center of the pupil. This creates a small ring of lighter black around the edge, which bleeds into the iris slightly. Finally, add extra details to the eyelashes, and darken edges that you want to set apart, such as where the white of the eye meets the skin.

Multiple-layered **COLORS AND BLURRED EDGES GIVE THE EYE A LIFELIKE APPEARANCE.**

Heads: Approaching Skin Tones & Hair Wet-into-Wet

Adding layers of skin tones while the previous layer is still wet can be an interesting way to paint a portrait. Here is a simple approach to painting a head as well as a variety of color schemes to create hair and skin tones.

QUICK PROCESS FOR PAINTING A HEAD

To paint this man's portrait monochromatically, create a color scheme that captures the look of fair skin, such as rose, raw sienna, and white. Then paint in layers—adding a deeper, less diluted value over the wet lighter value quickly builds a value range and creates some interesting shapes as the water flows more naturally. It is harder to control, but it results in an organic, watery feel.

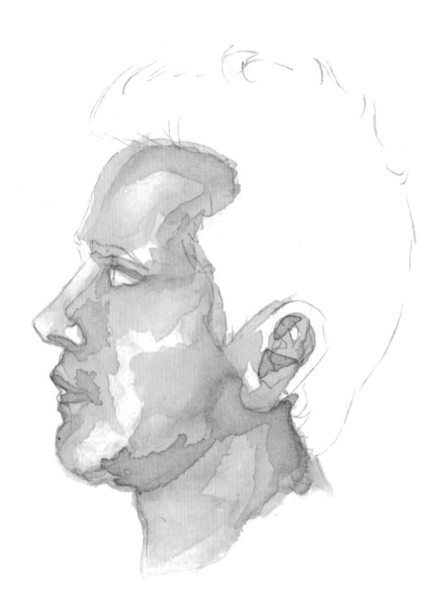

CHANGING THE

direction

OF YOUR BRUSHSTROKES CREATES TEXTURE.

Follow the same process to paint the hair, tilting the paper slightly so the colors mix and run toward the top of the head. The first wash pokes through in places to create highlights, and the second wash creates midtones.

Let the wash dry, and then create the impression of hair growth by flicking an angled brush and changing direction. If any areas look too dark, brush clean water on them, and use paper towel to remove pigment. The natural flow of pigment into water creates interesting, pleasing, and irregular textures and shapes.

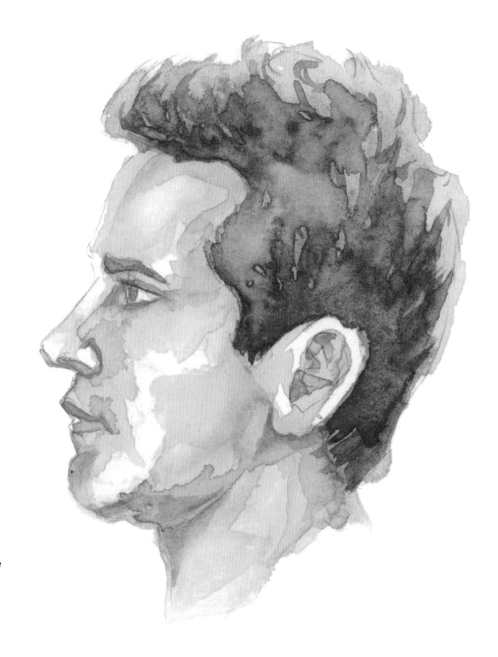

tip

USE A PENCIL TO FILL IN DETAILS, SUCH AS THE PUPIL.

Adding Various Color Schemes

There are so many skin tones and hair colors and styles that it would be impossible to showcase all of them. Using the same processes as on pages 92-93, you can paint myriad portraits. Here are the colors you can use to paint the various facial complexions and hair in these four portraits.

SKIN TONES

**YELLOW OCHRE
+ ALIZARIN CRIMSON**

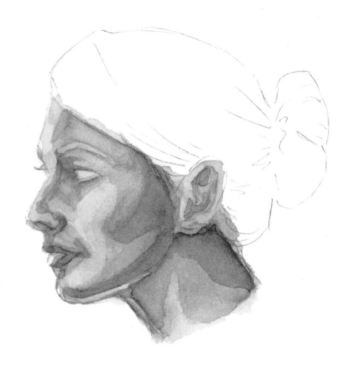

**RAW SIENNA
BURNT SIENNA
+ PERMANENT ROSE**

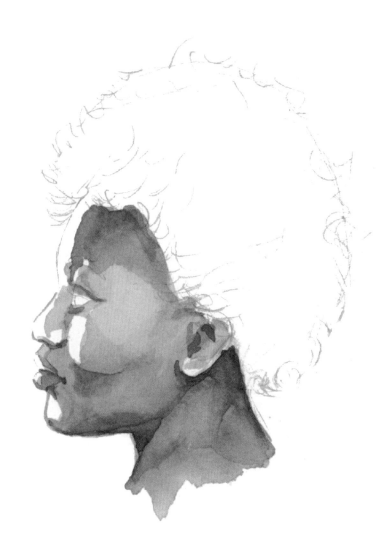

SEPIA
+ BURNT SIENNA

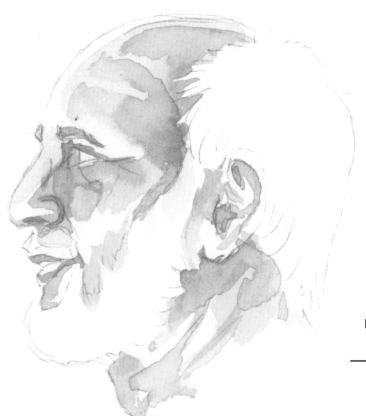

SEPIA
PERMANENT ROSE
+ CHINESE WHITE

HAIR

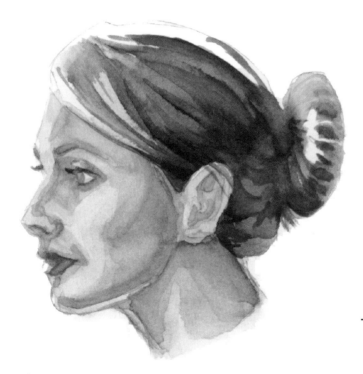

SEPIA
ALIZARIN CRIMSON
+ CRIMSON FOR THE HAIR BAND

INDIGO
+ BURNT SIENNA

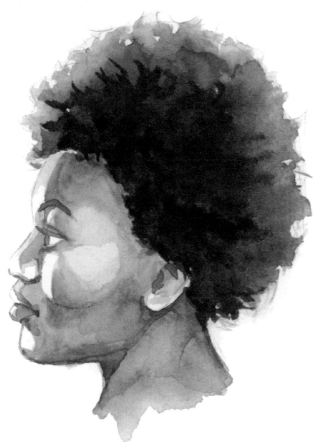

ALIZARIN
+ INDIGO

VARYING YOUR
BRUSHSTROKES
CAN CREATE
interesting
TEXTURES, LIKE IN
THE HAIR ON THE
BOTTOM RIGHT.

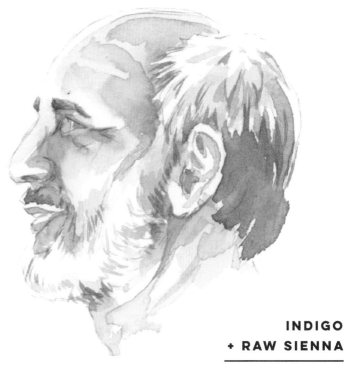

INDIGO
+ RAW SIENNA

Layering Colors in a Face

The secret to creating rich, vivid skin tones is to layer the colors by working from lighter, more transparent colors to darker ones. The portrait on the next few pages was created using this reference photo. Take a look at the photo, follow the steps, and then recreate your own layered portrait at home. Use this reference photo or another one—it's up to you!

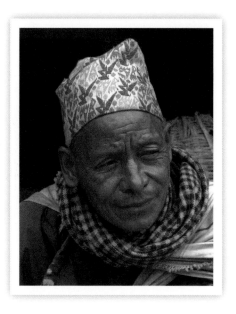

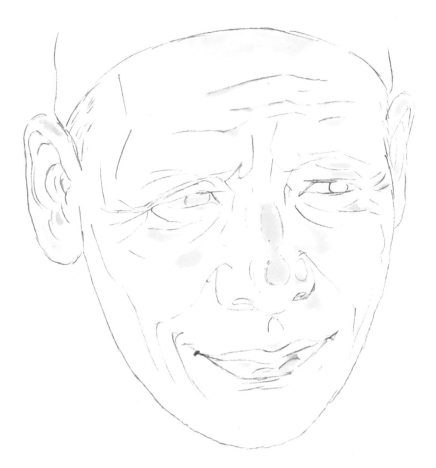

Notice where the face reflects the brightest light, and apply masking fluid there.

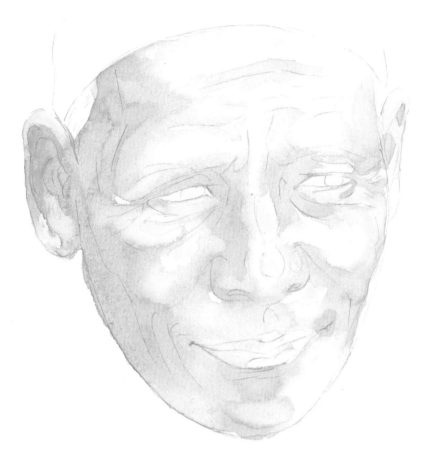

Select a color or mixture of colors that matches the lightest shades you see on the face. Paint the entire face with a watery mixture of this color (yellow ochre in this case). Add more concentrated paint in this same color where you see shadows. If you overpaint an area, lift out some color with a paper towel, or brush the area with clean water, and let the water blossom create a highlight.

When this layer is dry, apply the next-darkest color you notice in your subject matter. Paint the shadows and wrinkles. In areas that shouldn't have hard edges, use a damp brush to soften the edges. Again, blot with a paper towel or dab with a clean brush to lighten any areas that look too dark.

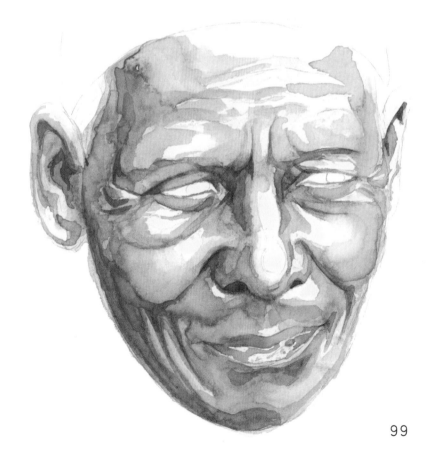

99

ADDING HIGHLIGHTS

After the last wash dries completely, remove the masking fluid so you can see the highlights. It is easier to work when you can visualize the full range of values.

Now pick the darkest value you see, and paint the most shadowed areas in the face. These are small; a little dark goes a long way. Add more pigment to your deepest darks, such as the nostrils, eyelashes, and ear canal, and add more water to lighten the color in areas that don't need to be quite as dark, like the eyes. Reddish tones create darker values and more contrast in the lips.

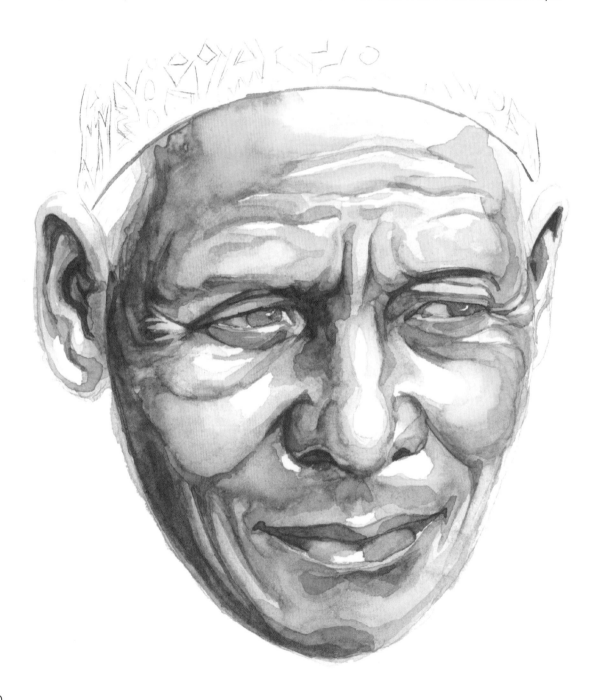

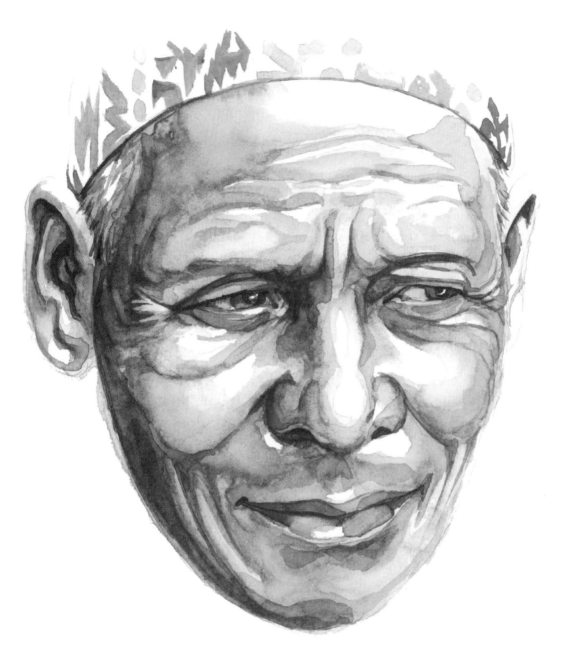

Just the details need to be added now, such as patterns on the man's hat, his hair, and his pupils. Paint loosely, and consider whether you need to add any additional details.

tip

BY WORKING IN LAYERS, YOU BUILD UP COLORS TO CREATE A FACE WITH FAR MORE DEPTH AND WARMTH THAN ONE PAINTED USING A SINGLE COLOR.

The Impact of Distance on a Figure

Painting a figure in the foreground is different than painting a figure in the background. Figures in the foreground have more contrast in them, and the colors stand out from the background. Figures in the distance tend to lose some of their details and vibrancy, and they fade into the colors of the background.

Look at this side-by-side comparison, and consider how you might change your approach if you want the figure to be the main subject of your painting versus a background element.

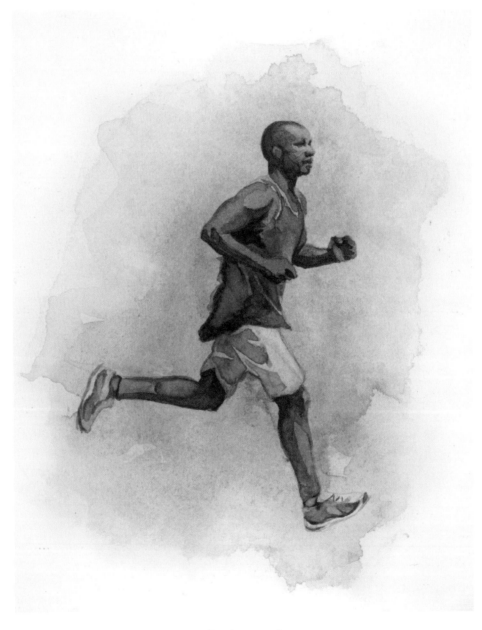

Background

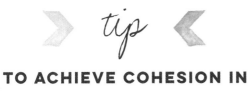

TO ACHIEVE COHESION IN A PAINTING, WORK SOME BACKGROUND COLORS INTO THE FOREGROUND.

Foreground

Notice the difference in detail, contrast, color vibrancy, and depth between the foreground and background. You might prefer the foreground figure, but remember that painting people in the background of a scene is just as important as a compelling foreground focal point. If the background figures have the same properties as the foreground, the painting will appear flat and unrealistic. If you want to create people even farther in the distance, you can reduce more details.

PORTRAIT & STRUCTURE

Now let's look at an approach to painting a scene that features both a person and a structure. Focus on one aspect at a time, and remember to layer the colors during each stage of the process. Lights come first and are painted in larger swathes, and then narrower and narrower regions are painted with increasingly darker values to create the shadows and details.

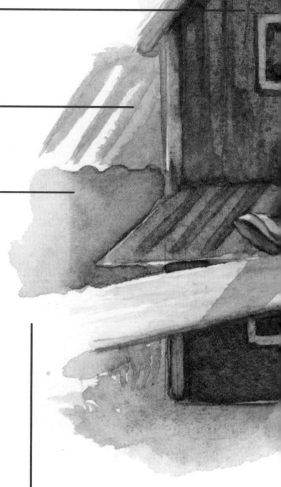

The background structures don't need too much detail; they should support the figure in the foreground, not compete for the eye's focus.

Use increasingly smaller brushes to work in smaller details.

Layer in midtone colors, working from light to dark.

The faded structure helps balance the painting.

MAKING THE FIGURE DARKER BY *covering up the light* **VALUES COULD RESULT IN THE BOY GETTING LOST IN THE DARK BACKGROUND. SIMILARLY, PAINTING BOTH THE BOY AND THE BARN WITH LIGHT, VIBRANT COLORS COULD MAKE THEM APPEAR FLAT.**

Covering the foreground with masking fluid enables your brushstrokes to be more loose and expressive while painting the background.

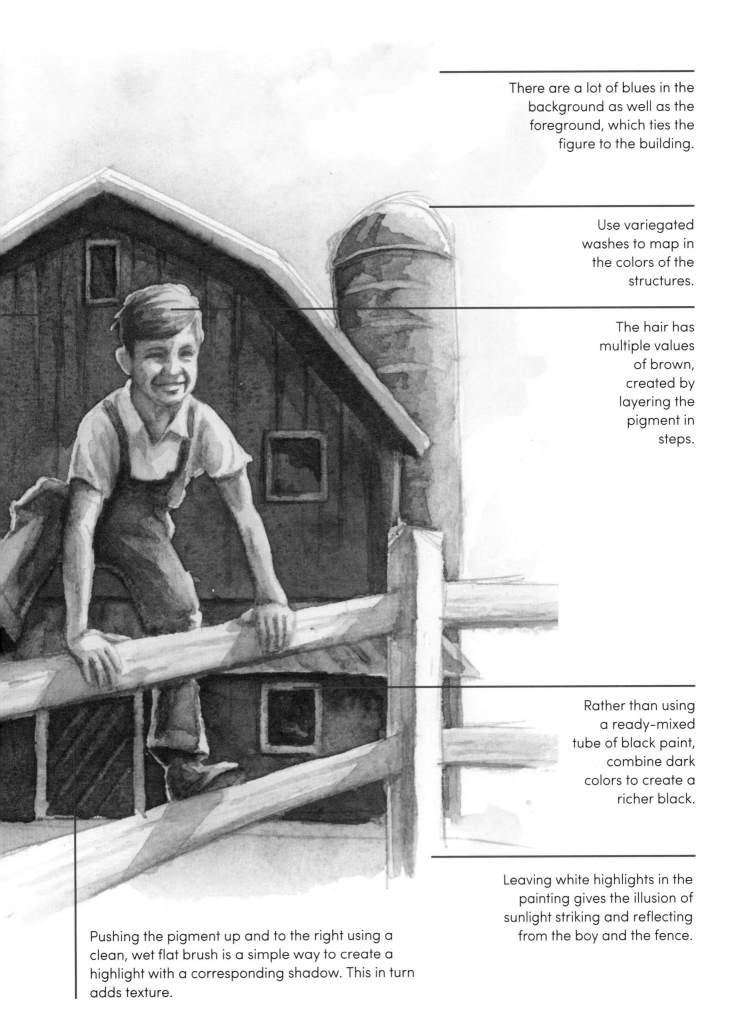

There are a lot of blues in the background as well as the foreground, which ties the figure to the building.

Use variegated washes to map in the colors of the structures.

The hair has multiple values of brown, created by layering the pigment in steps.

Rather than using a ready-mixed tube of black paint, combine dark colors to create a richer black.

Leaving white highlights in the painting gives the illusion of sunlight striking and reflecting from the boy and the fence.

Pushing the pigment up and to the right using a clean, wet flat brush is a simple way to create a highlight with a corresponding shadow. This in turn adds texture.

The Effect of Brightness

Now compare the painting on pages 104–105 with this version. The boy looks exactly the same, but the barn has been painted much more brightly. How does this change the dynamics of the foreground and the background? Is the contrast between them greater or less? Do the colors still work together? Even if the scene is designed and laid out the same way, altering the colors and values creates drastically different moods in a painting.

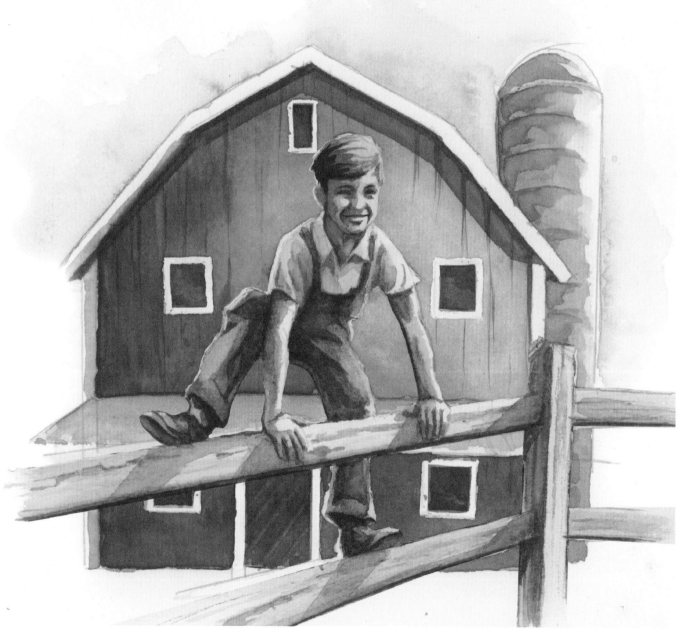

Painting Clothing

Painting bulky clothing brings a literal meaning to the concept of layering. Here you see the garb of a man contending with chilly elements.

Begin by adding masking fluid for the lighter colors in the coat, hat, and gloves. It's easier to paint washes loosely without steering around small shapes. Next create light-value washes in the hat, coat, and pants. Then paint darker values in the hat's pattern, the folds of the coat, and in the pants. Add deep shadows in the folds of the coat and gloves, and peel away the masking fluid.

Add light values to the coat and scarf, and then create dark values using a higher concentration of paint. Fade any sharp edges with a clean, damp brush.

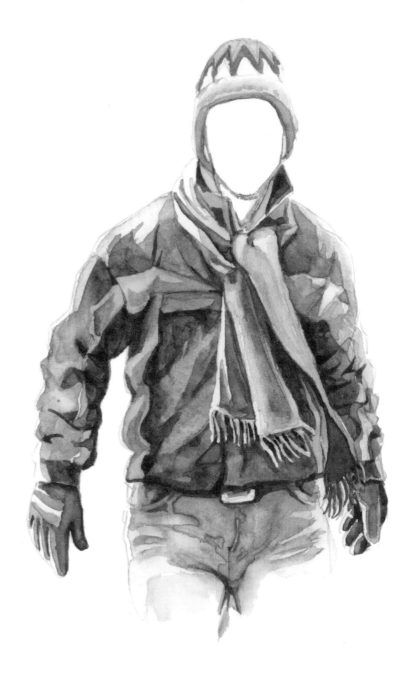

REMEMBER THAT YOU CAN ADD *clean water* **OVER A WASH IF THE PAINT LOOKS TOO HEAVY.**

COMBINING THE ELEMENTS

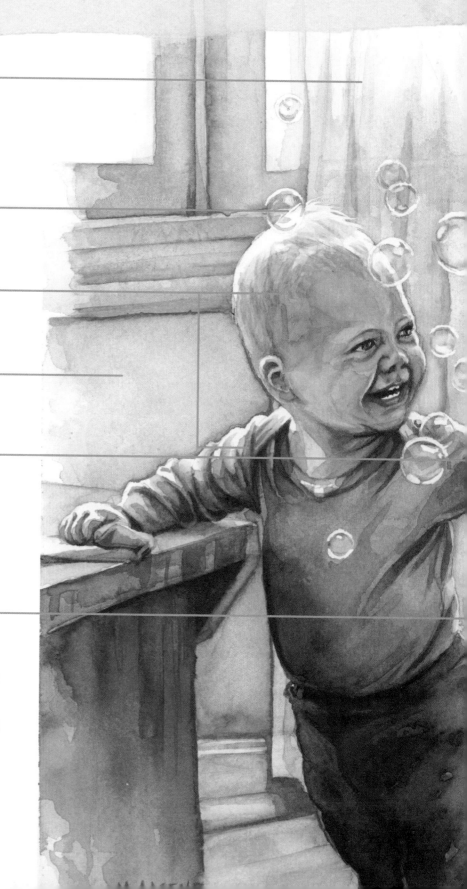

Hints of color contrast with the back wall and window to set apart the thin curtain from the red-and-white one.

Masking fluid forms the edges of the baby, her mother, the crib, and the bubbles.

Maintaining a cohesive use of color ties together the painting.

A variegated wash forms the background on a wet page.

The inside of the crib is painted using negative space.

Several washes of color achieve the darker colors of the clothes.

tip

LIMITING THE COLOR VARIETY MAKES A PAINTING LOOK LESS CLUTTERED AND SCATTERED.

After establishing darker and lighter values, middle values in the background can be added in addition to details in the room.

Don't worry about painting every strand of hair. Painting too technically removes the fun effects created when pigment and water intermingle.

Clean water can be brushed along the hair to blot out any unnecessary details.

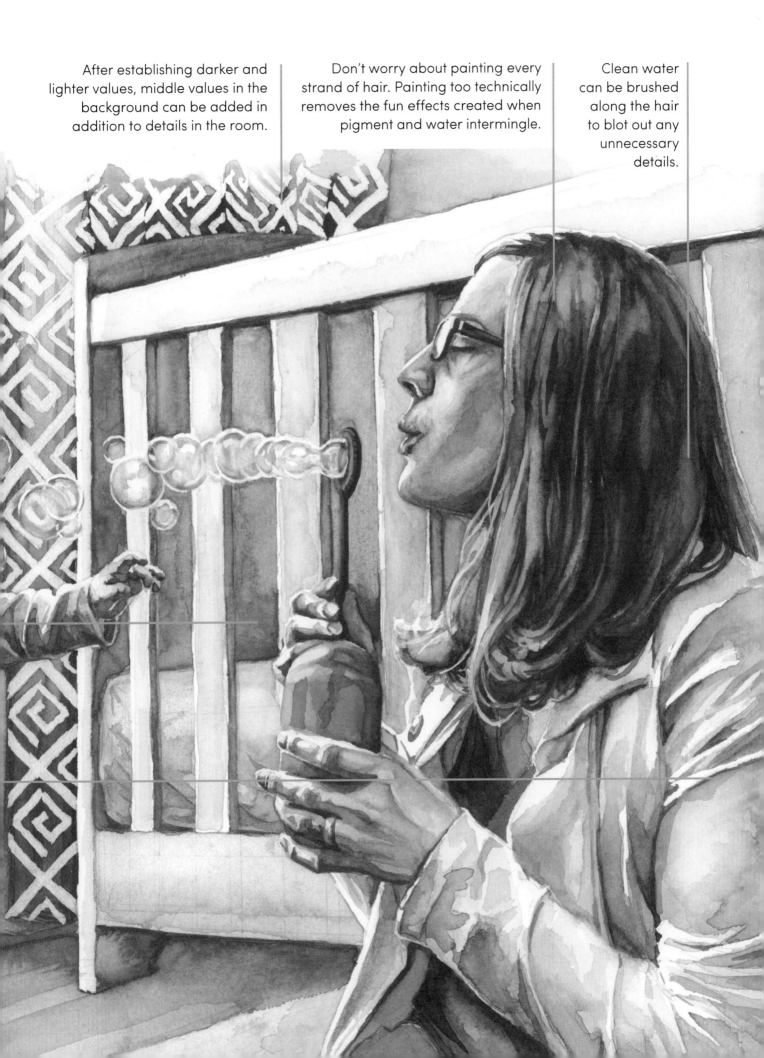

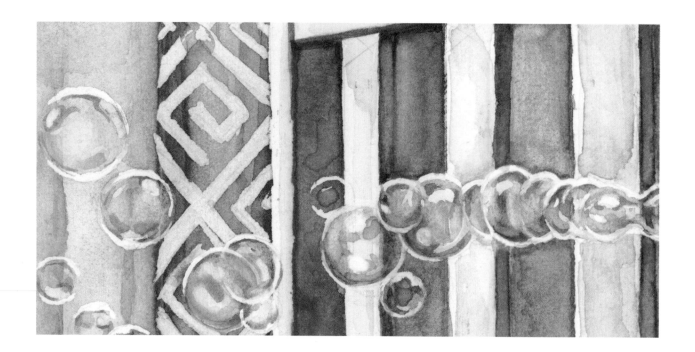

REFINING THE BUBBLES

Let's take a closer look at the bubbles. The secret to creating fragile and transparent bubbles is not to enclose any space. The white edges and highlights are curved, but none of them form a complete circle. That would appear unnatural to the eye.

If the bubbles appear too dark, as they often do, brighten them up with a brush and clean water. Gently scrubbing the inside of the bubbles removes some pigment and blurs the colors.

tip

IN A PAINTING WHERE YOU WANT EVERYTHING TO LOOK PROPORTIONATE, YOU CAN FIRST DRAW THE SCENE ON CHEAP DRAWING PAPER, WHERE YOU DON'T HAVE TO WORRY ABOUT OVER-ERASING OR STRAY MARKS. WHEN YOU GET THE COMPOSITION RIGHT, TRANSFER THE DRAWING ONTO WATERCOLOR PAPER USING A LIGHTBOX OR BY TRACING AGAINST A BRIGHT WINDOW.

ADDING TEXTURE TO A DRESS

This painting of a dress follows the same basic process as the winter clothes on page 107. Create layers from light to dark. (This dress includes more subtle shadows, however.) By applying redder shades and letting them run into clean water, the paint blends and creates an ethereal backdrop. Radiating brushstrokes give the impression that the folds originate from a focal point in the top-middle part of the dress, where the straps connect.

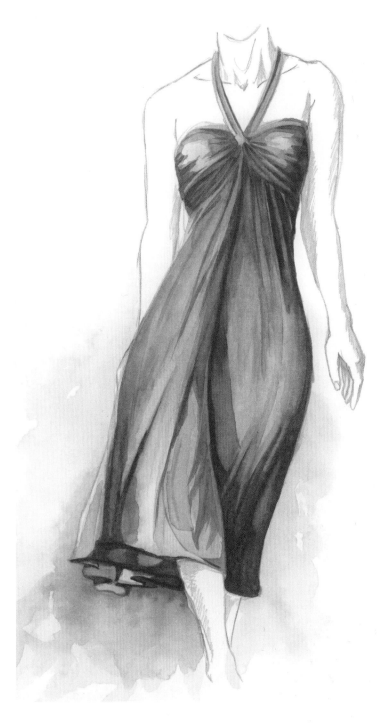

EVEN THOUGH YOU CAN'T SEE THE MODEL'S FACE HERE, YOU CAN TELL SHE HAS STRIKING *confidence* **JUST BY HER STRIDE!**

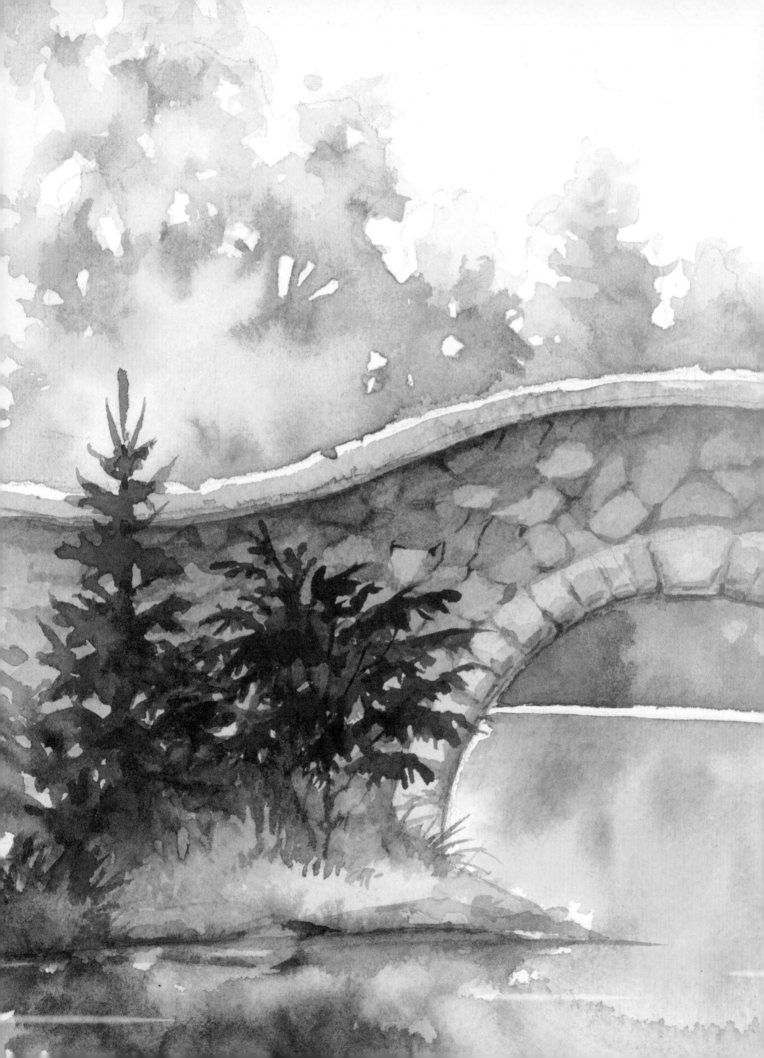

CAPTURING
Reflections

Simple Techniques Create Complex Reflections

People often think they have to paint with a large variety of colors to capture the accuracy of reflective surfaces. That can be the case, but more often it causes the painting to look muddy and you to lose control of your color palette.

Before learning how to paint reflective surfaces, let's quickly review some techniques.

Many reflective surfaces are curved and smooth. Take car paint and stemware, for example. As such, you will want your colors to feature gradients instead of hard edges. To achieve gradients, apply a wet brush with clean water along a painted line to fade the pigment into the water.

WHEN PAINTING *reflections,* **REMEMBER THAT ONE PIGMENT CAN LOOK LIKE MANY DIFFERENT COLORS DEPENDING ON ITS CONCENTRATION. LAYERING COLORS FROM LIGHT TO DARK AND LEAVING HIGHLIGHTS FROM EACH COAT OF PAINT CREATE THE ILLUSION OF A COMPLEX REFLECTION.**

Wine-ding Down

In order to paint a realistic reflective glass shape, you don't need to throw all of the colors in your palette at the paper. You can paint an elegant wine glass using just two colors.

Begin by drawing the shape of the glass and mapping out key areas of highlights and color contrast. The glass reflects almost pure white at its brightest spots; apply masking fluid over these areas to preserve the white of the paper while you paint. Notice that the large rectangular reflection highlight gets masked only where it does not overlap with the wine.

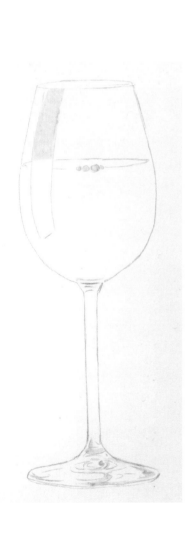

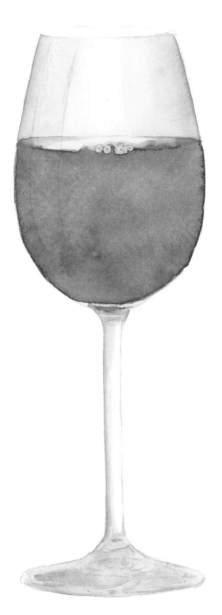

Next paint a flat wash for the wine, leaving the middle unpainted. To paint the bowl of the glass, use a small flat brush along the right and left edges. Then fade the color toward the middle by running a brush dipped in water along the inside edge of the paint.

Paint the entire base of the glass, and run a small flat brush up the right side of the stem to the base of the bowl. Dab some more concentrated paint onto the base, allowing the colors to mix into the still-wet paint. Fill in the rest of the reflective rectangle with masking fluid.

Wet-into-wet technique
(see page 25)

115

SOFT HIGHLIGHTS

Now fade another darker layer of pigment on the clear section of the glass, above the wine, and along the left edge of the stem to create subtle gradients. Then paint the shapes of the midtone values on the glass's base, bowl, and lip. You'll want to continue this "fade-to-the-middle" process for the wine too. Lift pigment from the bottom-right of the wine to create a soft highlight.

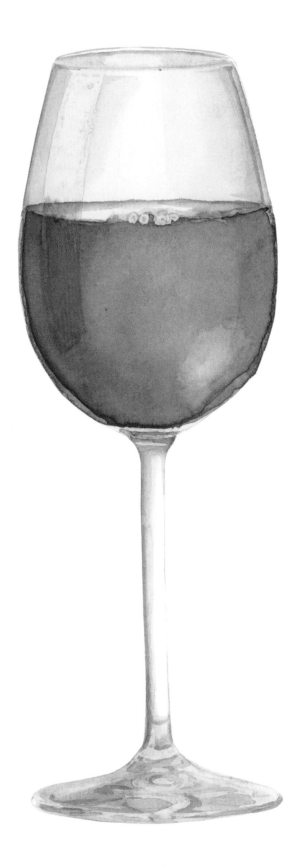

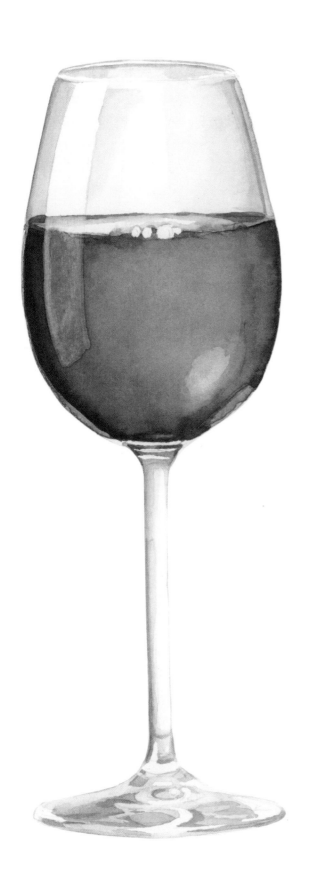

Darken the red color, fading to the middle and leaving some of the glass's edge unpainted to create small reflections. Also paint a tiny red stripe between the highlight areas at the base of the glass. Lift out the highlight with a paper towel, and then remove the masking fluid to reveal white highlights in the glass and the faded red highlight in the wine.

This last step requires deeply concentrated pigment and painting wet-into-dry. By painting the darkest values, you can create a large degree of dimensionality while applying pigment only to a small area of the paper.

Using your darkest values, paint the dark reflective colors and edges of shapes, such as the rim of the glass, along the edge of the stem, and the borders of the wine, leaving areas that overlap reflections unpainted. Look carefully at the dark values on the base, and paint the small, curved shapes individually.

THE KEY IS TO

stop before

YOU OVERPAINT!

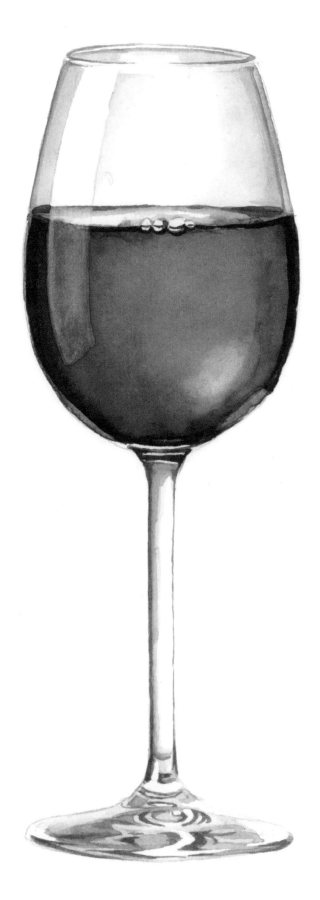

Building on Backgrounds

Now let's build on a spattered wash to create a reflective object. The techniques used on this bell include spray, spatter, wet-into-wet washes, masking fluid, and layering pigment values from light to dark.

Draw the shape of a bell. Use masking fluid to fill in the brightest areas that reflect pure white. Then dampen the middle of the page with a spray bottle. Paint a variegated wash on the wet area, allowing the paint to mix together and dilute. Then saturate the same brush with watery pigment, and use your thumb to spatter paint outward from the wash. You can do this multiple times.

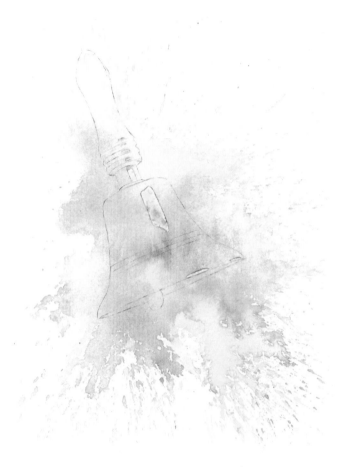

REMEMBER THAT *tilting* **THE BOARD TO MAKE THE WATER RUN HELPS CREATE A VARIEGATED WASH.**

After the first wash dries, create a second one over it, following the same process of spraying, applying a variegated wash, and spattering. Work in a narrower space around the bell shape, and create a more concentrated color and darker value to see the first wash around the edges of the second one.

This builds up the background and creates the second-lightest values on the bell (aside from the parts covered with masking fluid). Look to page 122 to see where these light values remain visible in the final painting!

CREATING MIDTONES

Using a round brush, lightly wet the area of the bell that you will add the next layer of shading to, avoiding the area where you want highlights. Now paint a more heavily concentrated mixture of pigment on the bell to create midtones. Spatter a little paint at the mouth of the bell to transition from the bell shape to the kinetic background splash. Follow the same process on the handle, creating some light values on its shaded parts.

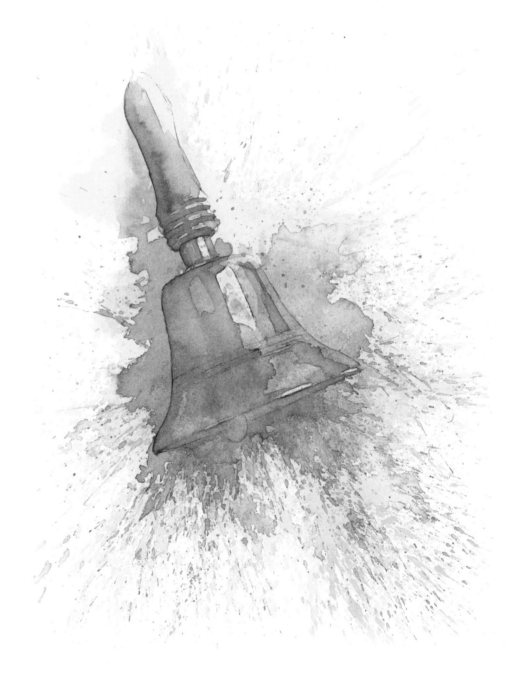

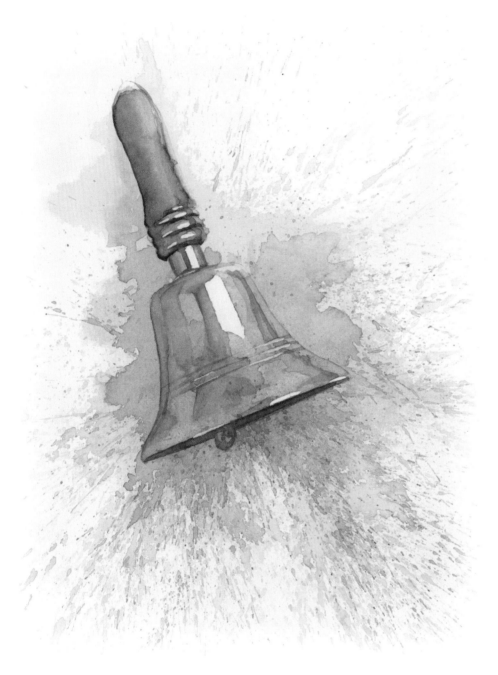

Continue to work from light to dark, adding dark reflections to the bell's shiny surface and painting the dark area underneath the bell.

As you continue to add darker values, maintain the same color scheme. Add darker tones to the handle to set it apart from the bell. Then peel away the masking fluid to reveal the white highlights.

A SINGLE COLOR SCHEME MAINTAINS *consistency.*

TYING IT ALL TOGETHER

Finally, apply your darkest colors to smaller areas, such as the underside of the bell. Spatter a small amount of this dark paint (in this case, brown) to tie it in with the background wash.

Notice how the slow buildup of layers creates the bell's reflective surface and allows multiple values to show. The splashy background visually represents the cheerful ring of a bell, and the outward spatter echoes that noise.

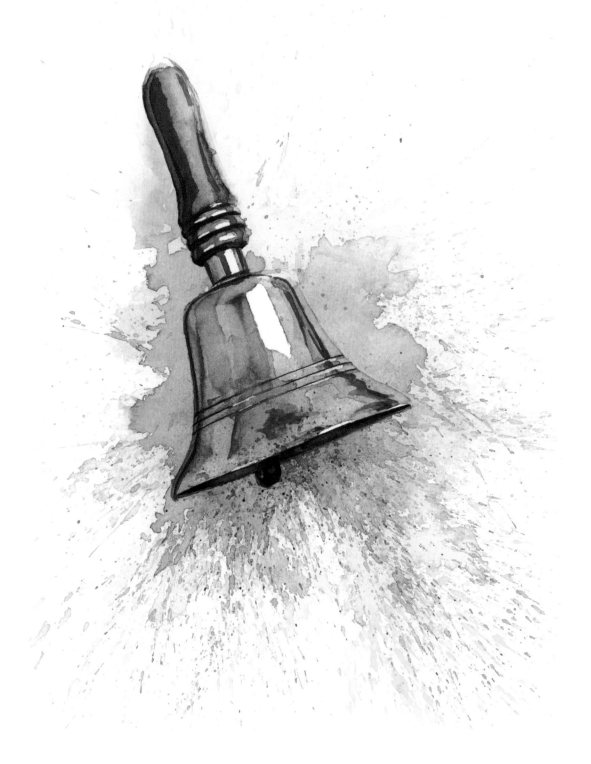

PAINTING A CLEAR REFLECTIVE SURFACE ON A DARK BACKGROUND

Painting a transparent, reflective object is fairly simple when the background is white. However, when the object is in front of a darker background, the background color features heavily in the object.

Notice how the vase here is painted the same color as the background, and yet it takes its own shape; this is caused by the irregularities of the highlight values and the warped shapes the background colors take on when seen through the glass.

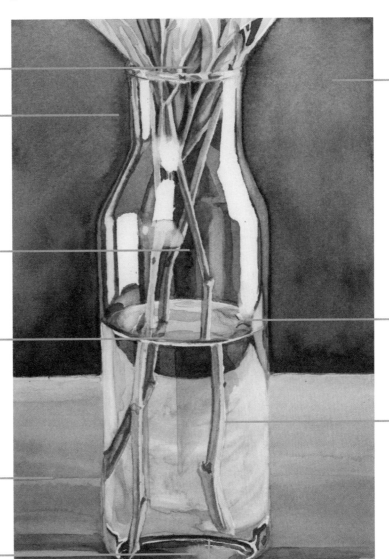

Create midtones in the leaves.

The blurred edges, created by wetting the area and pulling away paint with a brush or paper towel, capture the glossy look of a reflection of curved glass.

Let the lighter color of the first wash show through and "pop" the glass out from the background.

Notice the oval shape that indicates the surface of the water. This and the oval at the bottom of the vase are painted using the same colors as the background.

Running a flat natural brush horizontally creates texture and color variations on the table.

Light reflects the contrasting colors of the wall and table, which helps ground the vase.

Use a graded wash to create the background, with the darkest values at the bottom.

The glass picks up the greenery's reflections.

Apply masking fluid to the highlights and stems.

Darker pigment running along the masking fluid on the edges creates contrast.

REFLECTING ON REFLECTIONS: TWO-COLOR REFLECTIVE SURFACE

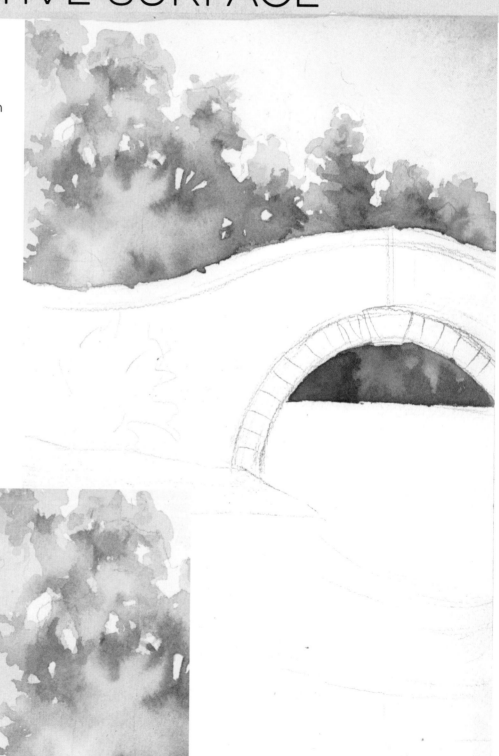

A landscape over water often reflects features from its surroundings.

Begin by painting from back to front. Wet the sky, paint a little blue in the top-right corner, and let it bleed downward.

Create the autumn foliage by working on one section at a time. On your dry paper, switch back and forth between light and dark, letting the colors overlap and mix to create variegated washes. The light colors dominate the top of the page, and the bottom features darker colors.

The next-closest
feature is the bridge.
Apply a variegated
wash, and then paint
various colors for the
rocks' shadows.

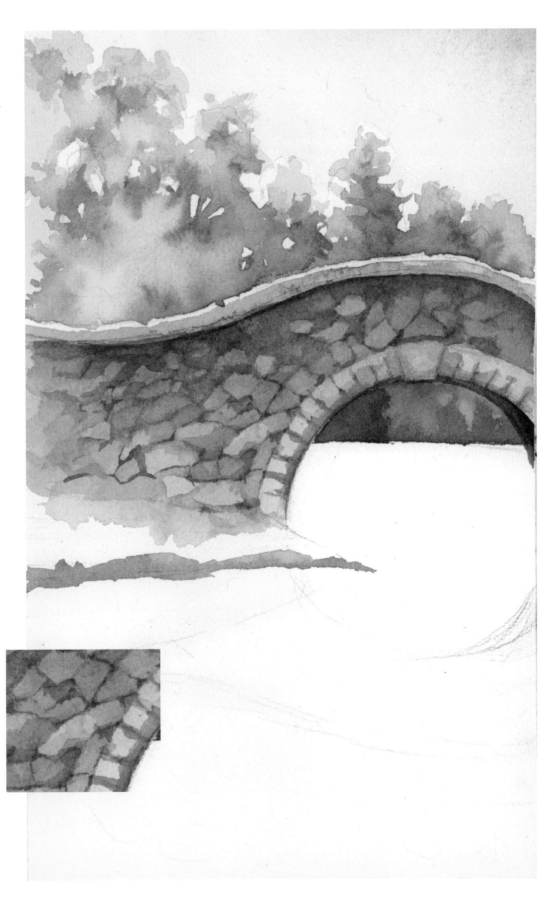

Paint in negative
space between
the rocks to give
the bridge texture
and form.

FADING COLORS

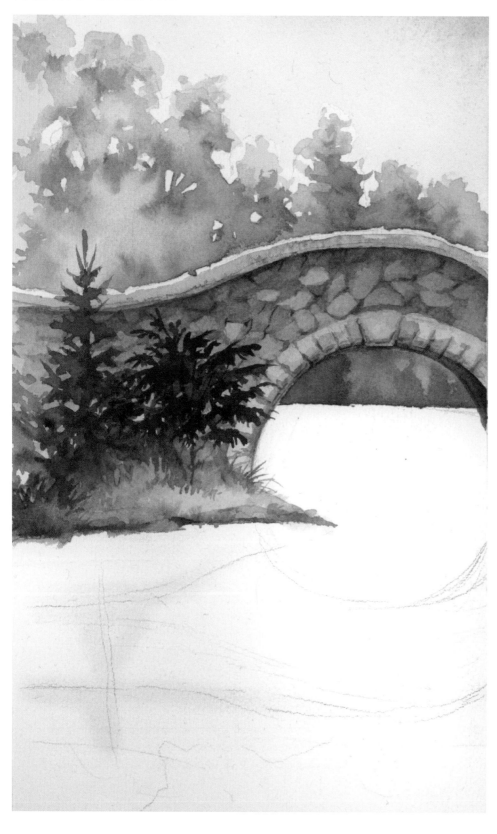

To create the illusion that colors fade as objects recede into the background, use more concentrated pigment as you move into the foreground. Using an angled brush, paint the foliage in front of the bridge using the wet-on-dry technique (see page 25). The green and red trees provide contrast and focus the viewer's eyes.

Create a light colored wet-into-wet wash for the various shades of grasses, and paint vertical irregular strokes below the trees.

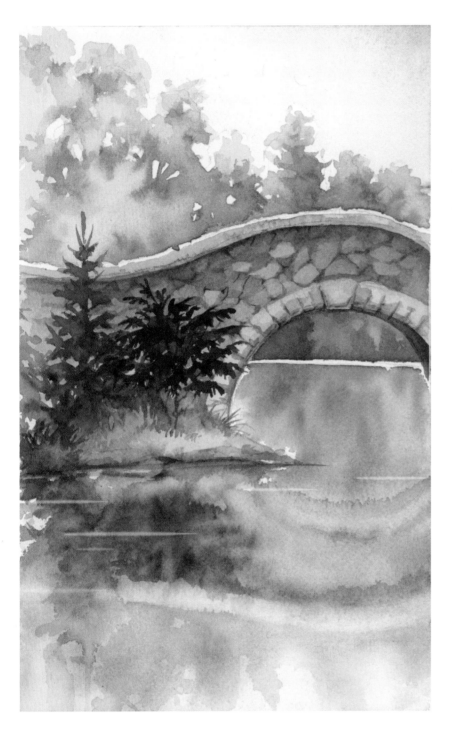

Now create the reflection in the water. First, dampen the entire page using a flat synthetic brush. Painting from background to foreground, and lightest value to darkest value, roughly paint the colors from the landscape into the water below. The colors and shapes don't have to be exact; they should just correspond.

Finally, while your paper is still wet, run a small, flat, slightly damp brush in streaks across a few areas of the water to create waterlines and subtle detail. Remember to stop before you overwork your painting! The pigment flowing in the paint creates beautiful effects that can be destroyed with too many details.

PAINTING *wet-into-wet* CAUSES THE COLORS TO BLEED AND CREATE SOFT, UNDEFINED EDGES WHILE STILL HOLDING THEIR BASIC POSITIONS. THIS GIVES THE PAINTING THE WATERY LOOK OF A REFLECTED LANDSCAPE.

About the Author

In 2004, Maury Aaseng began his career in freelance illustration in San Diego, where he created graphics for young-adult nonfiction. His work since then has expanded into instructional line-drawn illustrations, cartooning, medical and anatomical illustration, and more traditional media such as drawing and watercolor. Now living in Duluth, Minnesota, with his wife and daughter, Maury uses watercolor to create posters for opera shows, custom paintings for individual clients, and signs for landscaping projects for county soil and water utilities. His inspiration is heavily drawn from the outdoors, where Maury spends much of his time observing and photographing the natural scenes and wildlife that he uses for subject matter.

His work has won recognition in the Upstream People Gallery, a juried exhibition, and a collection of his watercolor work was featured at the Great Lakes Aquarium gallery. Maury has worked with Quarto Publishing for the past four years. He draws from his painting and drawing experience to create books that demonstrate these techniques to budding artists.